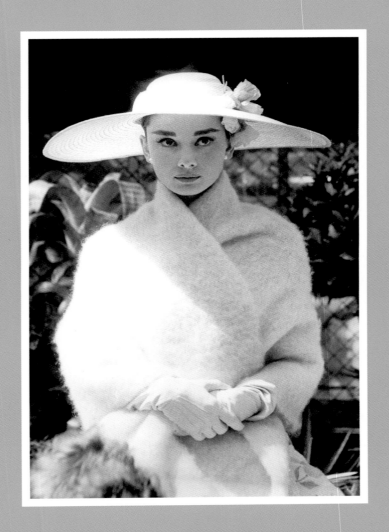

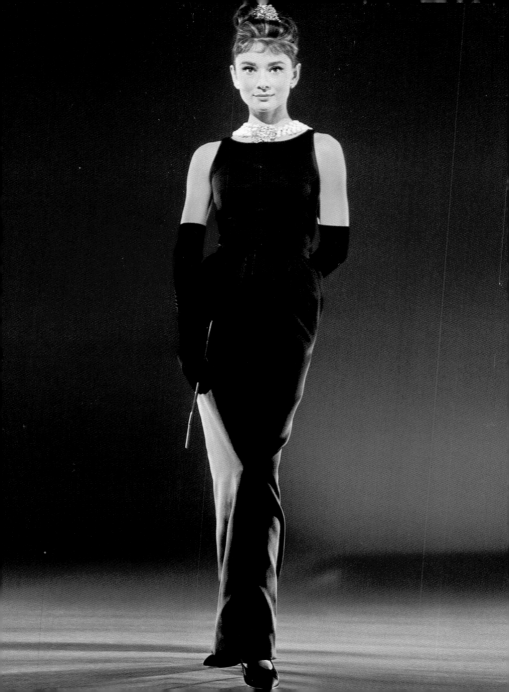

# AUDREY

## AND

# GIVENCHY

## A FASHION LOVE AFFAIR

CINDY DE LA HOZ

RUNNING PRESS
PHILADELPHIA · LONDON

To Mom, whose love of leopard print
and high heels inspired my love of fashion.

© 2016 by Cindy De La Hoz

Published by Running Press,
A Member of the Perseus Books Group
All rights reserved under the Pan-American and
International Copyright Conventions

Printed in China

Books published by Running Press are available at special discounts
for bulk purchases in the United States by corporations, institutions,
and other organizations. For more information, please contact the
Special Markets Department at the Perseus Books Group,
2300 Chestnut Street, Suite 200, Philadelphia, PA 19103, or call
(800) 810-4145, ext. 5000, or e-mail special.markets@perseusbooks.com.

ISBN 978-0-7624-6017-5
Library of Congress Control Number: 2015956780

E-book ISBN 978-0-7624-6018-2

9  8  7  6  5  4  3  2  1
Digit on the right indicates the number of this printing

Designed by Amanda Richmond
Edited by Jessica Fromm
Typography: Sentinel, Avenir, Stringfellow, and Lulo

Running Press Book Publishers
2300 Chestnut Street
Philadelphia, PA 19103-4371

Visit us on the web!
www.runningpress.com

# CONTENTS

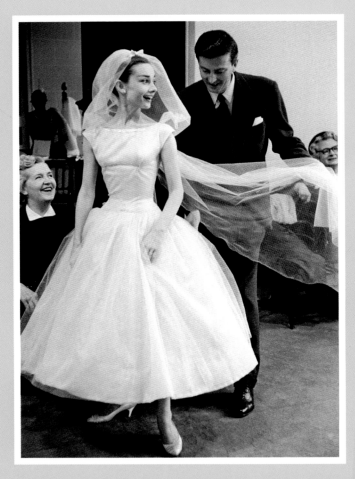

**A FITTING WITH GIVENCHY FOR** *FUNNY FACE* (1957). Designer and star got along famously from the start. Audrey once said of her friend, "There are few people I love more. He is the single person I know with the greatest integrity."

# INTRODUCTION

*P*ERHAPS NO TWO ARTISTS HAVE HAD A greater impact on contemporary fashion than Audrey Hepburn and Hubert de Givenchy. Together, they popularized trends that brought fashion into the modern age, including the steadfast Little Black Dress. Over the course of their forty-year friendship and professional partnership, Audrey Hepburn became a style icon. The looks she wore came to be regarded as "timeless," and she continues to be the ultimate fashion role model for millions around the world. This enduring boon to the fashion world all sprang from Audrey and Givenchy's brilliant, collaborative partnership, which began at the start of their careers, when they were merely in their mid-twenties.

In 1953, Audrey won the hearts of movie audiences everywhere with her performance in the romantic fairy tale *Roman Holiday*. Not only was she the most endearing personality to hit the screen in years;

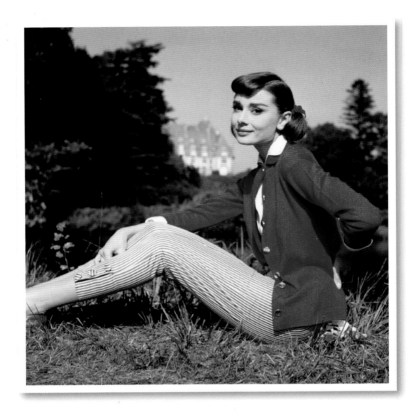

she was a genuine original. She looked so different from the other leading ladies of the day. Neither blonde nor buxom in the manner of Marilyn Monroe, Jane Russell, or even a young Elizabeth Taylor, this "gamine" stood out as uniquely interesting. The problem for Audrey was that Hollywood costumers were

not exactly designing for her silhouette at the time. Even though she wasn't a designer herself, there was one thing Audrey knew in spades when it came to fashion: what worked for her. She didn't care to pad out her naturally slim figure, and she favored the comfort of flats to high heels (preferably half a size larger than needed so that they would be less prone to wear). Givenchy said, "She always took the clothes created for her one step further by adding something of her own, some small personal detail which enhanced the whole." In *Roman Holiday,* she added flair to her Edith Head costume by wearing a belt with her skirt and tying a scarf around her neck. Audrey wanted to convey who she was through her clothes.

Fortunately for Audrey, her next film, *Sabrina,* would lead her to a lifelong partner in this endeavor. In search of authentic French fashions that her character in the film would wear, she turned to the up-and-coming Hubert de Givenchy. Though the designer had never heard of Audrey before, he agreed to let her wear his designs in the movie. Beginning with the high-necked *"décolleté Sabrina"* style featured in

the film, Givenchy clothes worn by Audrey Hepburn started trends, with women everywhere copying her look. Fortunately for us, the clean lines, comfort, and lack of pretention of her style happen to flatter most body types.

Givenchy later said, "In film after film, Audrey wore clothes with such talent and flair that she created a style, which in turn had a major impact on fashion. Her chic, her youth, her bearing, and her silhouette grew ever more celebrated, enveloping me in a kind of aura or radiance that I could never have hoped for. The Hepburn style had been born, and it lives today." Audrey, meanwhile, always felt that Givenchy's designs enhanced her work: if she dressed the part, she could act the part. "[Givenchy] is far more than a couturier, he is a creator of personality," Audrey said in 1956.

Audrey and Givenchy's tastes and sensibilities complemented and enhanced each other. The essence of their approach to fashion is perhaps best surmised by Audrey's son, Sean Ferrer, when he said, "She saw the clothes he created as the beautiful vase that would

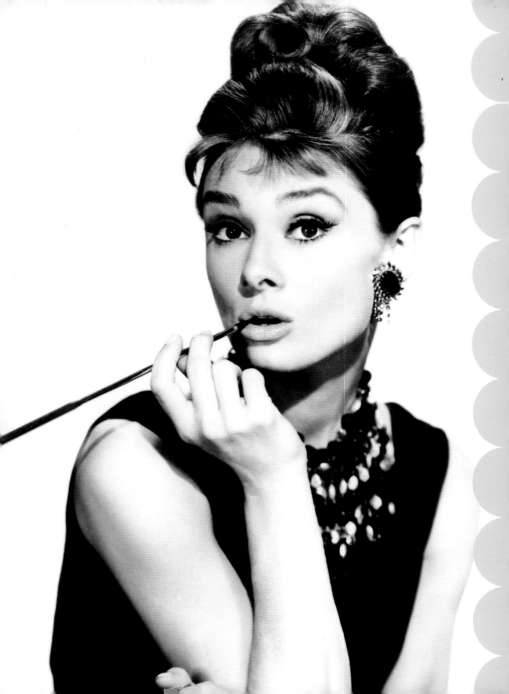

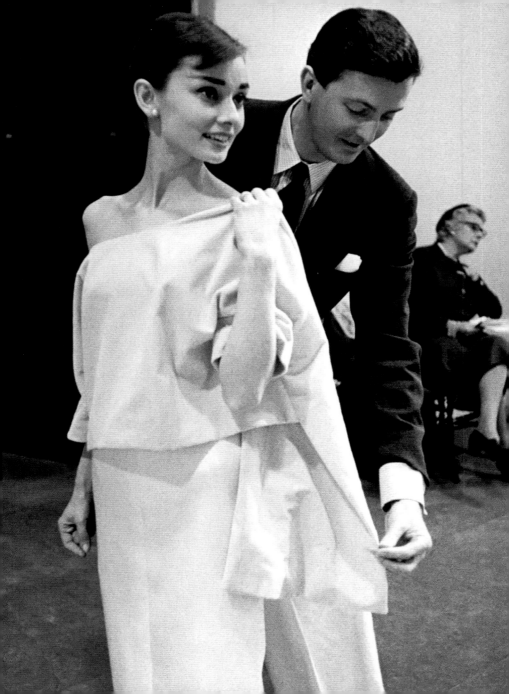

enhance a simple field flower, whereas he viewed them as the vase that is kept simple so that nothing will detract from the natural beauty of the flower itself. . . . [That] elegance had its roots in both their inner values. It came from the right place. It wasn't a way to be noticed but a way to be humble." Together, they were a brilliant meeting of minds—and they became the best of friends.

This book is a salute to Audrey and Givenchy's work both onscreen and off. It features profiles of the seven classic films on which they collaborated (plus two late-career Audrey movies), and a section covering their greatest off-screen fashion hits for awards shows and events. It showcases the styles that kept women running to stores hoping to capture a bit of Audrey's magic in the 1950s and '60s, and which today continue to inspire and delight.

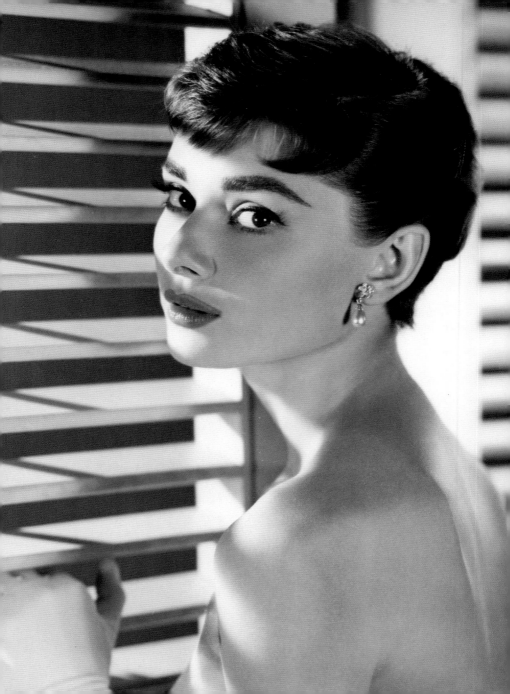

# SABRINA

*P*ARAMOUNT PICTURES USHERED IN THE new year of 1953 by presenting American audiences with a new star: Audrey Hepburn in *Roman Holiday.* At that point, the twenty-three-year-old actress had appeared in a handful of films and been the darling of Broadway starring in Anita Loos's adaptation of Colette's *Gigi.* It was her showcase in *Roman Holiday,* however, that would eventually charm audiences the world over and win Audrey recognition as that year's Best Actress Oscar pick.

Paramount quickly lined up a new project for her, based on Samuel Taylor's hit play, *Sabrina Fair.* Enacting the part of a chauffeur's daughter who falls in love with the handsome scion of a wealthy Long Island family, Audrey transforms from a timid waif into a sophisticated, worldly, exquisitely dressed young woman. Though Paramount's head designer, Edith Head, was working on the film, director Billy Wilder

wanted Audrey to have genuine French couture for the scenes set after Sabrina's return from study abroad. The studio arranged for Audrey to fly to Paris on a mission to bring back suitable fashions for *Sabrina*. She asked to meet with one designer in particular.

At twenty-six, Hubert de Givenchy was an emerging designer inspired by the fashions of Jacques Fath and Cristóbal Balenciaga, and who had been the director of Elsa Schiaparelli's boutique for four years. Motivated to start his own business based on luxury *prêt-à-porter*, he had opened the House of Givenchy on February 2, 1952. Audrey was already a fan, and with money earned from *Roman Holiday* she had made her first extravagant gift to herself: an original Givenchy coat. The designer and his staff were hard at work on a new collection in the summer of 1953, when Givenchy agreed to meet with "Miss Hepburn" at his atelier. *Roman Holiday* not having been released in France yet, he had never heard of Audrey; he thought that the appointment was with the already-legendary Katharine Hepburn. Audrey was blissfully unaware of any such confusion, though, and excitedly arrived

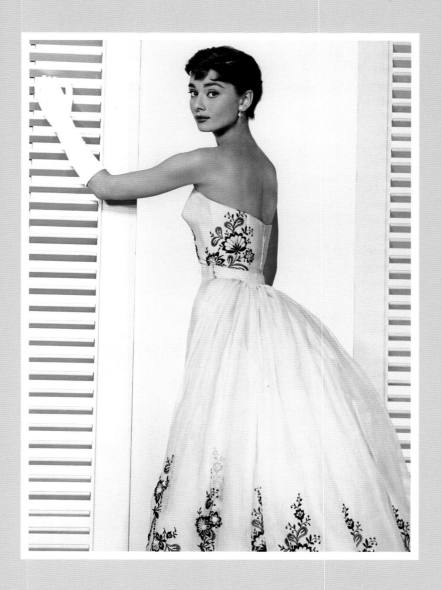

for their meeting at the appointed time.

Givenchy later recalled, "When the door of my studio opened, there stood a young woman, very slim, very

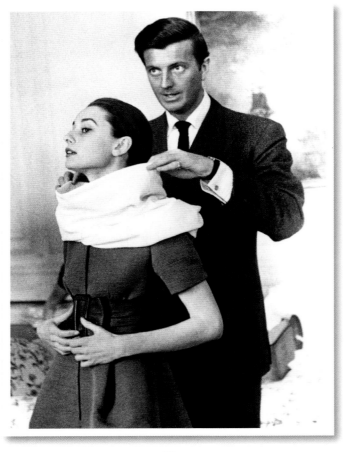

AUDREY AND GIVENCHY

tall, with doe eyes and short hair and wearing a pair of narrow pants, a little T-shirt, slippers, and a gondolier's hat with red ribbon that read *Venezia*." The designer was immediately taken with this vision—and her personality—but he was still unable to oblige when asked to design new fashions for Audrey to wear in *Sabrina*. Undeterred, Audrey asked if she could browse the completed garments of his collection in progress. As she began trying the clothes on, it became apparent that Audrey was an ideal model for Givenchy's fashions—the clothes fit her perfectly directly off the racks. The synergy between star and designer was affixed, and Givenchy took Audrey to dinner that evening. They would discover that they had many traits in common besides their shared taste in fashion, including discipline, dedication, loyalty, and graciousness. It was the beginning of a deep friendship and professional partnership that would last until Audrey's death forty years later.

Audrey returned to Hollywood with three Givenchy originals from the designer's fledgling collection to debut in *Sabrina*.

"If you should have any difficulty
recognizing your daughter,
I shall be the most sophisticated
woman at the Glen Cove Station."

—SABRINA FAIRCHILD

SABRINA HAS JUST RETURNED TO AMERICA from Paris and made her way to Long Island by train. Her expected pickup from the station by her father, the chauffeur of the Larrabee family, is intercepted by David Larrabee (William Holden), the dreamboat of a business tycoon's son whom she had fallen head over heels in love with long ago. David never noticed Sabrina from her perch in the rooms above the garage—and certainly does not recognize her as the ultra-chic vision before his eyes at the train station.

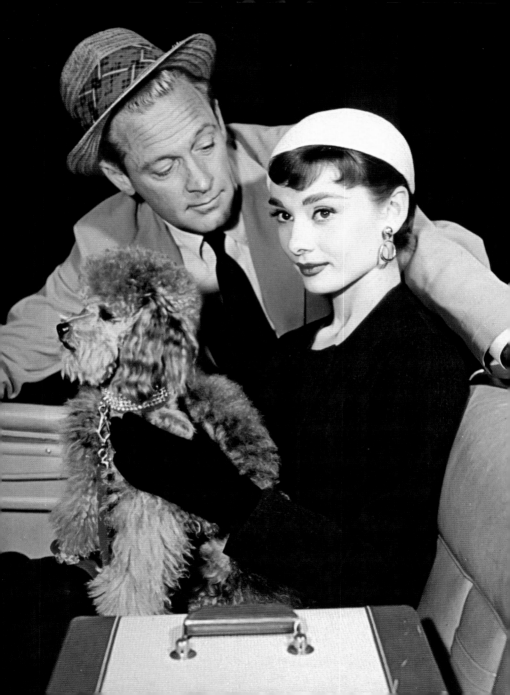

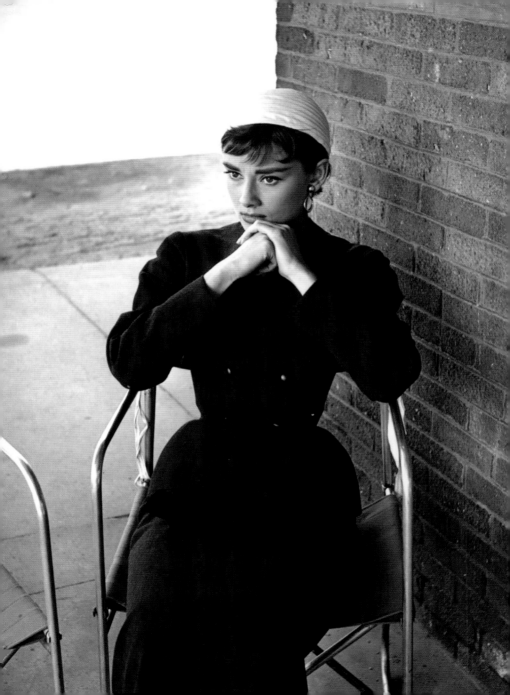

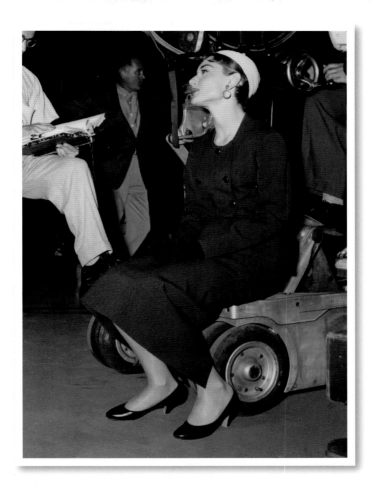

THE ACTRESS BEHIND THE SCENES. THE AUDREY-
and-Givenchy fashion collaboration first appeared
onscreen in the form of this Oxford-gray wool suit.
Slim and cinched at the waist and accessorized
with a turban and hoop earrings, the ensemble
represents the birth of a fashion icon.

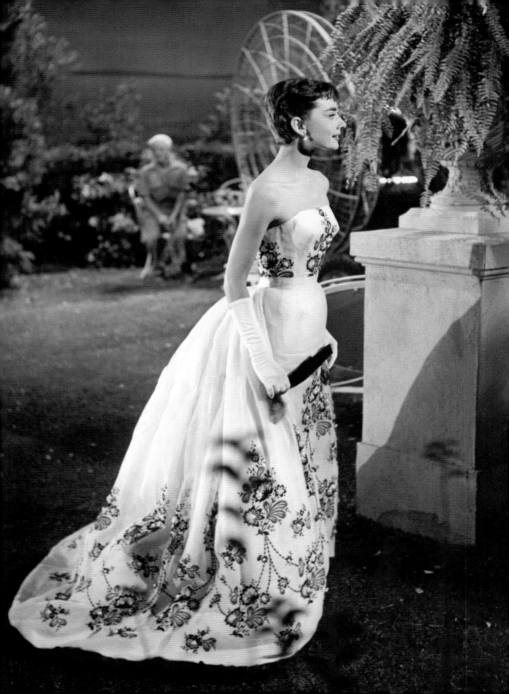

SABRINA PAUSES BEFORE MAKING
her entrance to the Larrabee party.
Givenchy-for-*Sabrina* dress number two
was a white strapless organdy ball gown
featuring a detachable overskirt and jet-bead
embroidery. This arresting look makes
Sabrina the belle of the ball.

**SABRINA OWNS A SMALL POODLE IN**
the film, but the hounds shown in these photos
were used solely in advertisements, not onscreen.

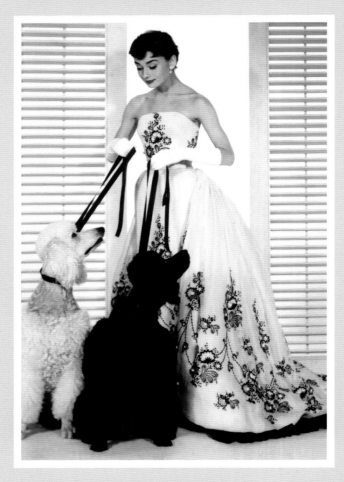

AUDREY AND GIVENCHY

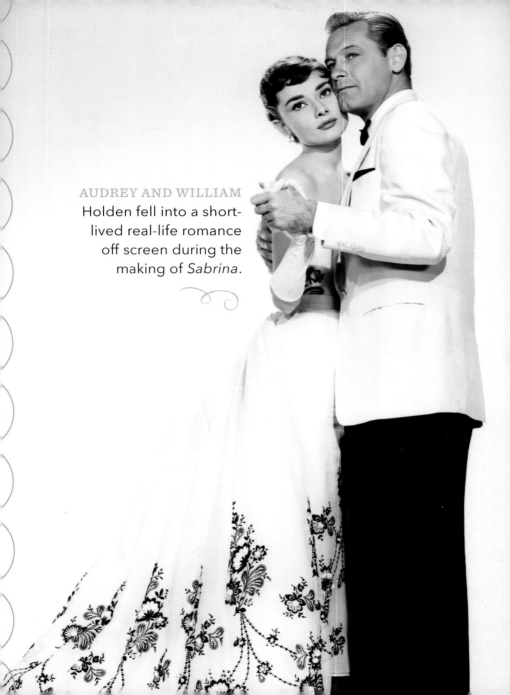

**AUDREY AND WILLIAM**
Holden fell into a short-lived real-life romance off screen during the making of *Sabrina*.

FOR SABRINA'S DATE WITH
big brother Linus (played by Humphrey
Bogart), Audrey wore a black satin evening
dress, deeply cut in the back and high in the
front. This neckline became known as *"décolleté
Sabrina"* and started a new trend for fashionable
women to copy. The dress was decorated with
bows at the shoulders and Audrey paired it with
a fitted cap (also by Givenchy) that gave her a
vaguely catlike appearance. The "ballerina"
skirt, cut below the knees, around the
calves, became a staple for Audrey.

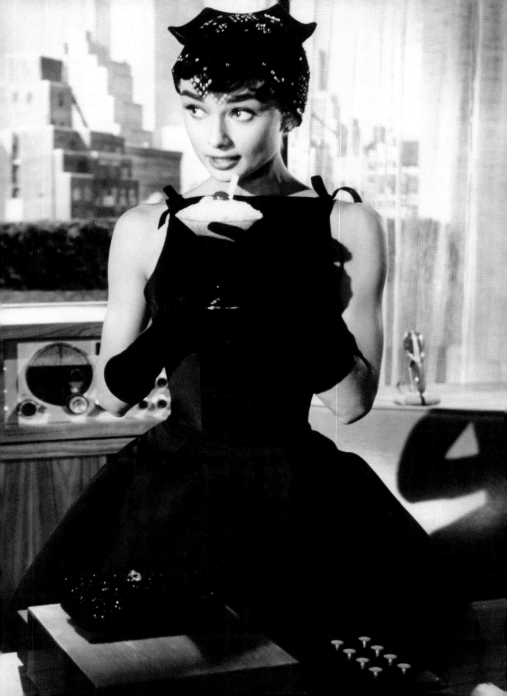

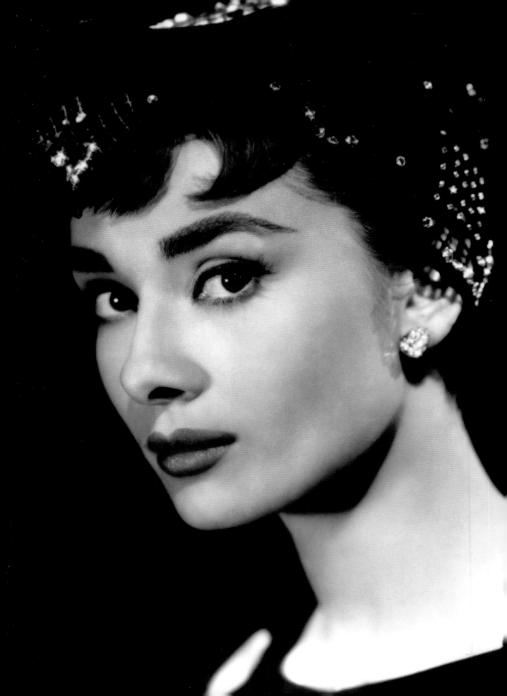

 ⤙ AUDREY SELECTED THIS
hat at Givenchy's salon in 1953.

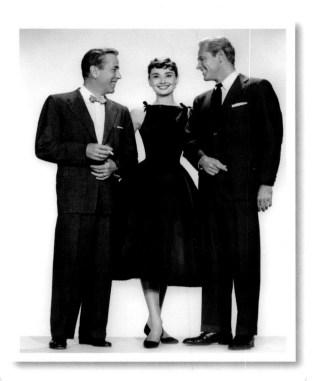

⤒ ALL SMILES WITH HUMPHREY BOGART
and William Holden. Off screen, Bogart
was none too fond of his younger costars.

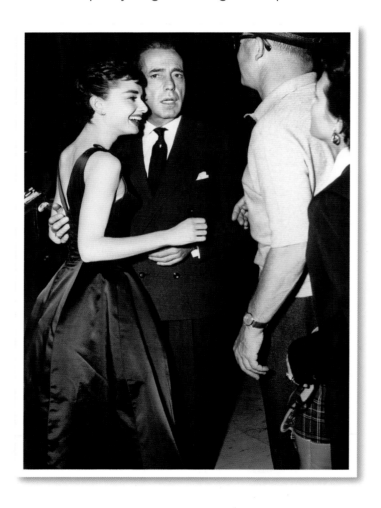

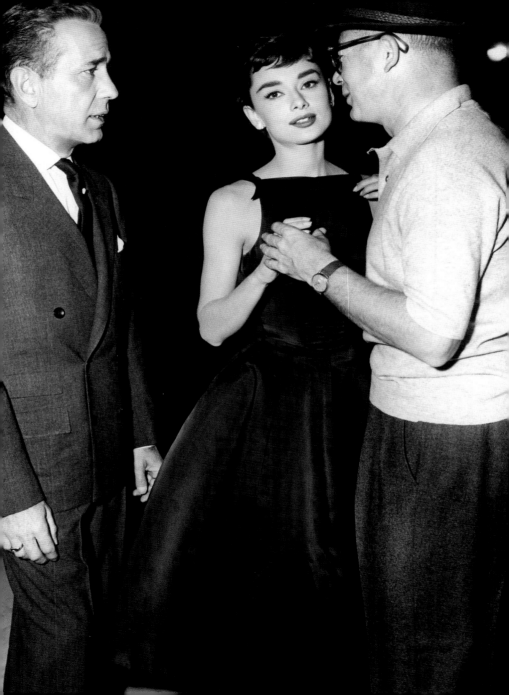

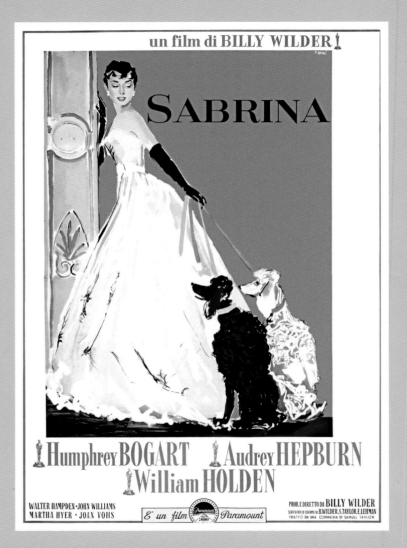

AN ITALIAN MOVIE POSTER FOR *SABRINA*.

here were more than just fashion stakes riding on *Sabrina*. Proving that *Roman Holiday* had not been a fluke, audiences flocked to see the rising star onscreen again, and Audrey received her second Academy Award nomination as Best Actress for *Sabrina*.

Including Audrey's nod for Best Actress, *Sabrina* received a total of six Oscar nominations. It took home only one—for Best Costume Design. Who collected the statuette? Edith Head. She was the director of Paramount's wardrobe department and had received sole screen credit for the movie's costumes. Audrey was mortified. Having such an acknowledgment for his work so early in Givenchy's career would have been a major coup, but he took this turn of events as only a true gentleman would. He did not become angry and simply went back to work. Audrey privately vowed to make it up to him. The fashion world was infinitely enriched by the pair's ability to surmount this early bump in the road. Their professional partnership could have ended then. Instead, they would next work together on arguably the most iconic fashion film in movie history.

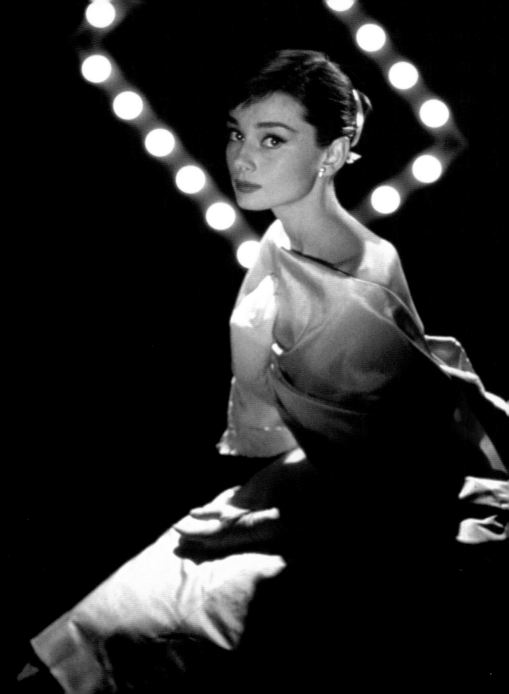

# FUNNY FACE

*T*HOUGH SHE HAD BECOME ONE OF THE most bankable stars in Hollywood, Audrey took time off from making movies after *Sabrina*. She starred in *Ondine* on Broadway, which earned her a Tony Award for Best Actress, and fell in love with and married her *Ondine* costar, Mel Ferrer. Audrey returned to the screen with Ferrer in an adaptation of *War and Peace* in 1956, and then prepared herself for a signature role that returned her to her roots as a dancer, opposite none other than the legendary Fred Astaire.

In *Funny Face*, Audrey played Jo Stockton, a young woman working in a Greenwich Village bookshop when it is overtaken by a swarm of people from *Quality* magazine seeking an "intellectual" backdrop for their statuesque but empty-headed leading model (played by Dovima). Photographer Dick Avery (Fred Astaire) sees past Jo's sack-like attire and "funny"

face; he believes she can be the *"Quality* Woman" that the magazine is hunting for to showcase the fashions of Paris's leading designer. After much resistance, Jo places herself in the hands of *Quality's* battery of stylists and makeup artists, and a stunning "bird of paradise" emerges.

This fairy tale set in the world of fashion gave Audrey the opportunity to work with Givenchy at full force. Edith Head was again the film's official costumer, but this time the screen credits made it clear that "Miss Hepburn's Paris Wardrobe" was by Givenchy. As in *Sabrina, Funny Face* features a transformation of Audrey from gamine to goddess, so the star and designer set to work creating a fittingly sumptuous wardrobe. What they created was revolutionary for 1957 because of its immersion into French haute couture. Six decades later, the jaw-dropping lineup of looks still holds up.

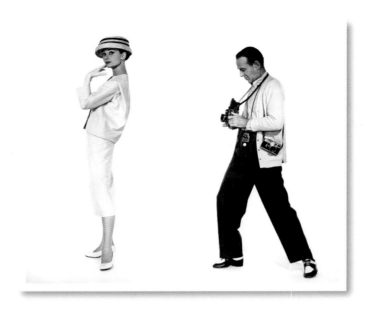

WITH FRED ASTAIRE. DIRECTED BY STANLEY Donen, *Funny Face* remains one of the most influential films of all time for aspiring designers, models, and photographers. It featured top models of the day, including Dovima and Suzy Parker, and photographs by Richard Avedon, then the chief cameraman of *Harper's Bazaar*. Audrey became a muse for Avedon in the 1950s and '60s. He once said, "I am, and forever will be, devastated by the gift of Audrey Hepburn before my camera. I cannot lift her to greater heights. She is already there. I can only record."

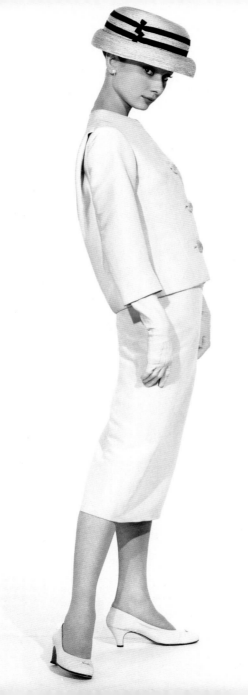

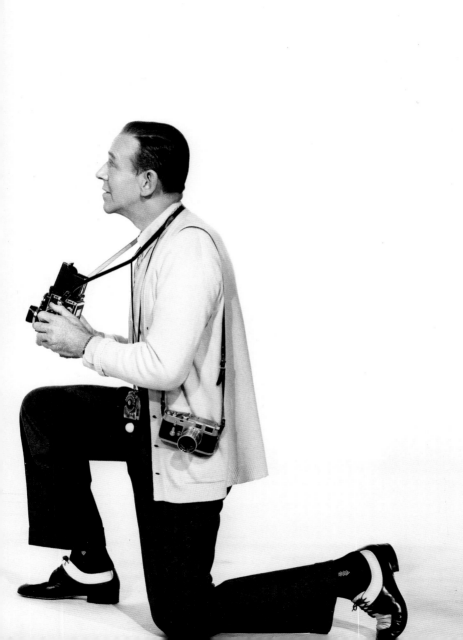

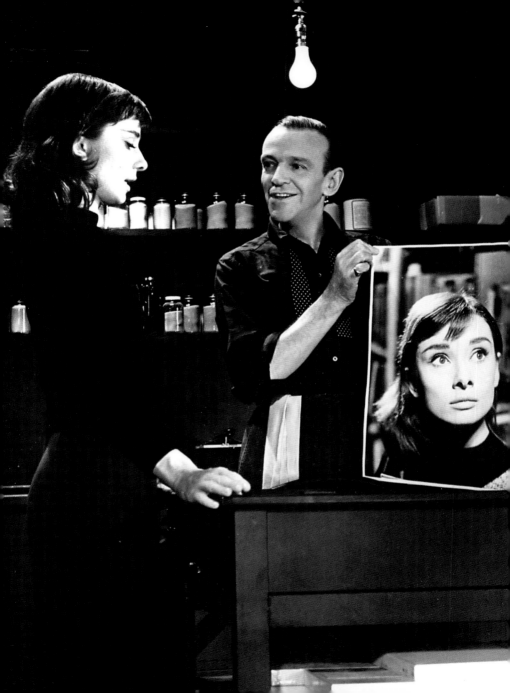

LIKE JO STOCKTON, AUDREY
was genuinely modest about her looks.
She said, "I have worked from twelve, and
I know my body well. I am not a beauty. Taken
one by one, my features are not really good."
Also like Jo, Audrey embraced her passion for
fashion: "Some people dream of having a big
swimming pool—with me, it's closets."

"My friends, you saw in here a waif, a gamine, a lowly caterpillar. We opened the cocoon, but it is not a butterfly that emerges . . . it is a bird of paradise."

–GLAM SQUAD REACTION TO JO'S MAKEOVER

LOOK NUMBER ONE IN JO'S TRANSFORMATION into the *Quality* Woman emerges in designer Del Val's studio in Paris. The catwalk curtains are drawn up to reveal a breathtaking Jo in a pink-and-champagne-colored satin dress, crowned in glory by a slim beaded headdress.

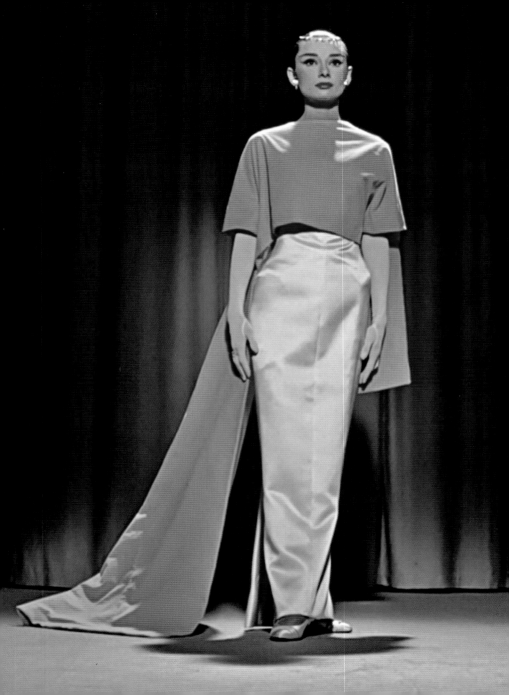

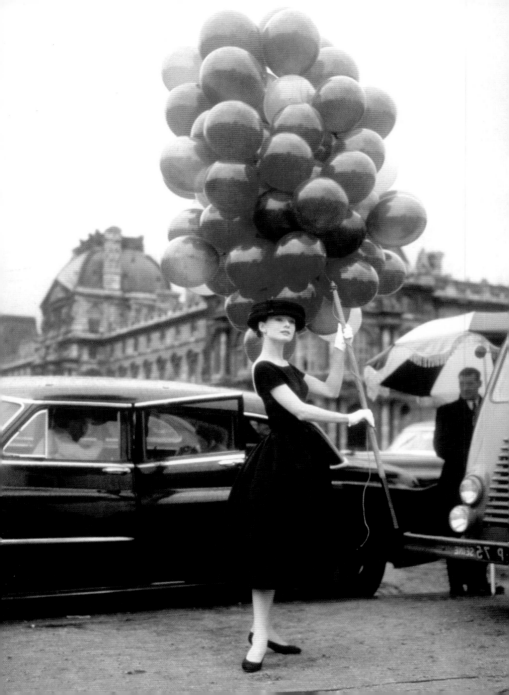

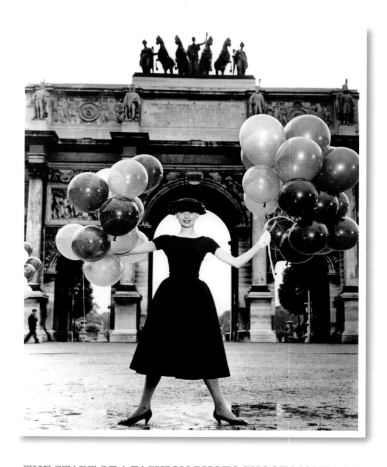

**THE START OF A FASHION PHOTO SHOOT MONTAGE** has Jo, Dick, and the *Quality* team shooting in the rain outside the Tuileries Palace. Colorful balloons clutched (and soon released) by Jo offset the dreariness of the day. Wearing a simple, elegant, ballerina-length black dress and little white gloves, Jo stands with legs akimbo for "the shot."

**THE ANNA KARENINA–INSPIRED** look includes a nine-tenths coat worn over a bouclé wool traveling suit, topped with a milk-chocolate-colored velvet Givenchy hat.

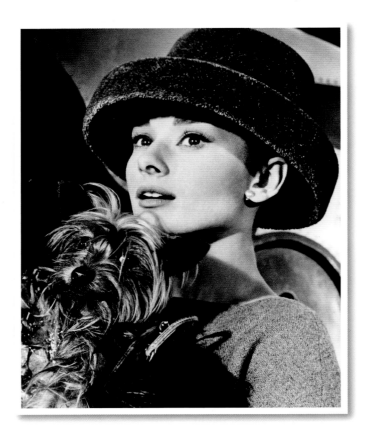

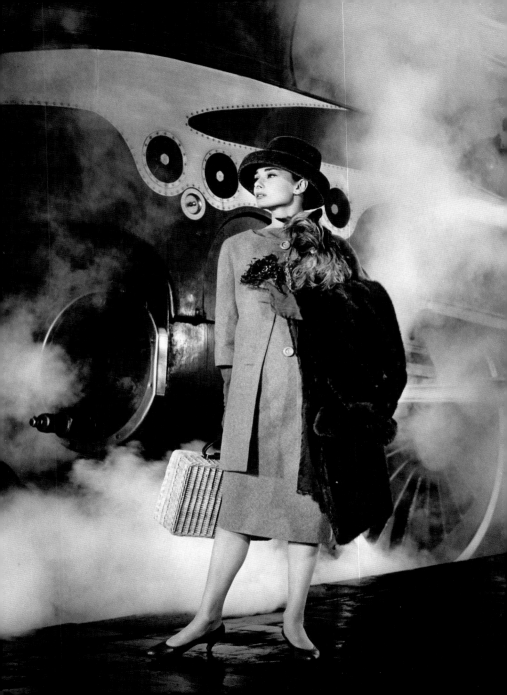

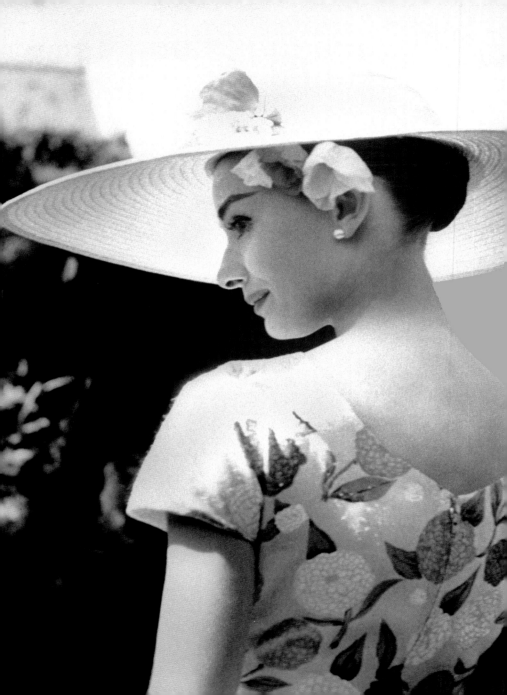

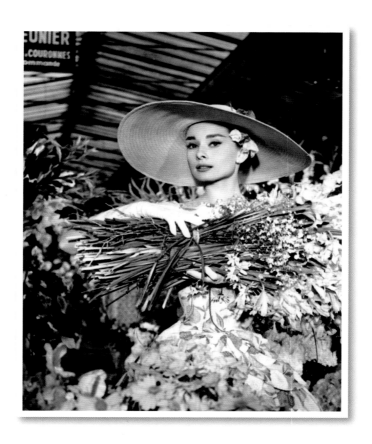

A GLORIOUSLY SUNNY LOOK FOR THE FLOWER
market, complete with gloves, sun hat, and armfuls
of blooms. In real life, both Audrey and Givenchy
shared a love of cultivating flowers.

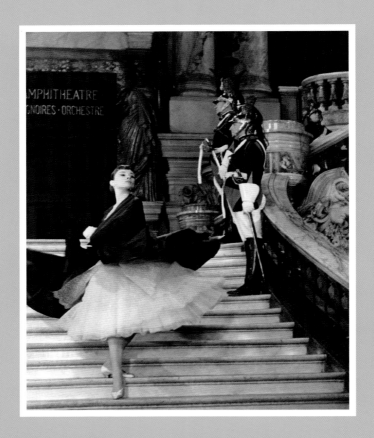

### EXITING A PERFORMANCE

of *Tristan and Isolde* in dramatic style.
The full skirt of her white dress peeks out
from beneath an eye-catching green cape.

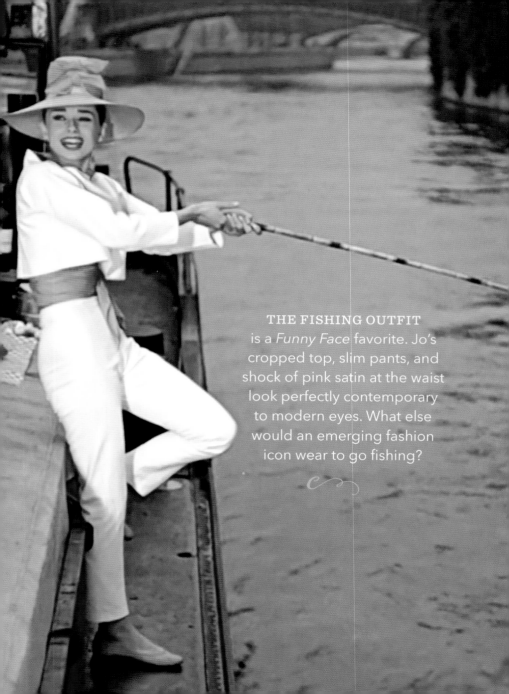

**THE FISHING OUTFIT**
is a *Funny Face* favorite. Jo's
cropped top, slim pants, and
shock of pink satin at the waist
look perfectly contemporary
to modern eyes. What else
would an emerging fashion
icon wear to go fishing?

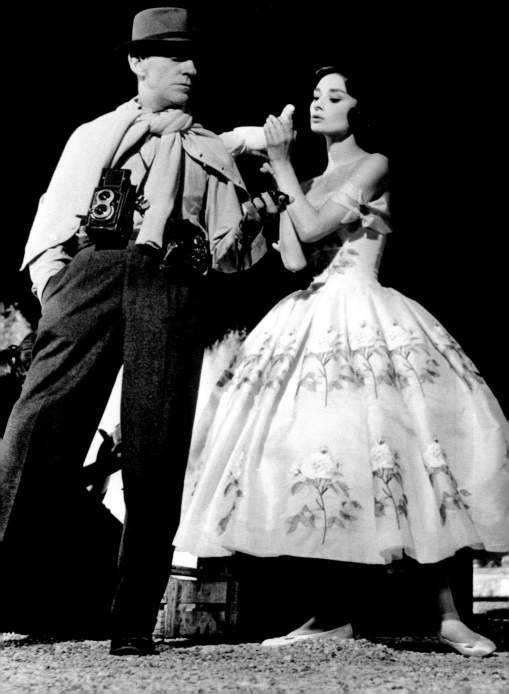

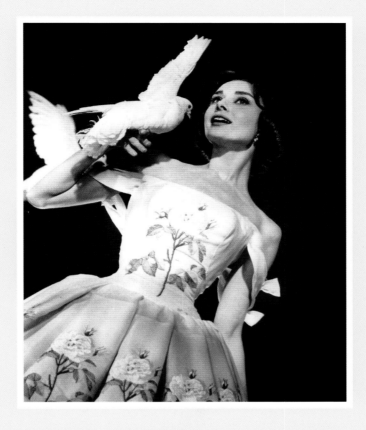

AS A PRINCESS AT THE BALL. WEARING A strapless drop-waist gown and sashes tied around her upper arms as mock sleeves, so divinely delicate is Jo that in the film she has the appearance of an animated storybook princess. "Get happy!" Dick shouts before snapping another perfect shot.

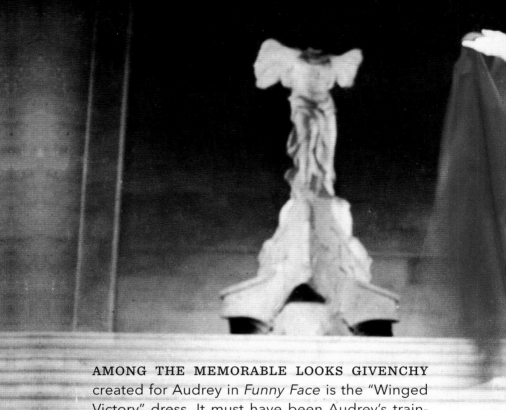

**AMONG THE MEMORABLE LOOKS GIVENCHY** created for Audrey in *Funny Face* is the "Winged Victory" dress. It must have been Audrey's training as a dancer that allowed her to showcase this stunning red chiffon, floor-length gown and sash while swiftly striding down a flight of stairs at the Louvre without a single misstep.

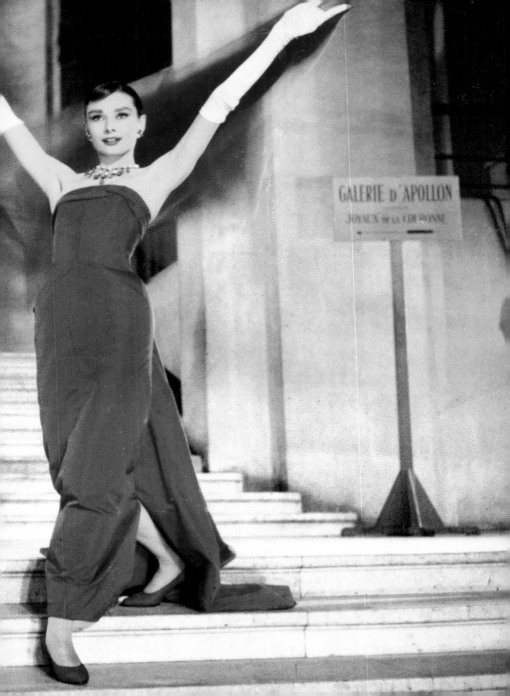

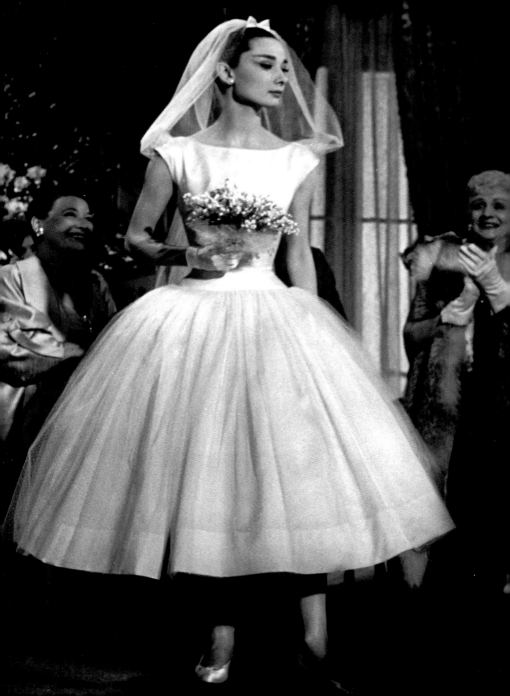

PERHAPS MOST HAUNTING OF ALL THE LOOKS featured in the film is the wedding dress that Jo wears at the end of the "take the picture" fashion montage sequence. Here Audrey and Givenchy popularized another trend: the tea-length wedding dress. With its drop waist and cap sleeves, it still looks contemporary. While many wedding dress trends of the 1980s and '90s appear horribly dated, a bride today could fashionably mimic the *Funny Face* bridal look.

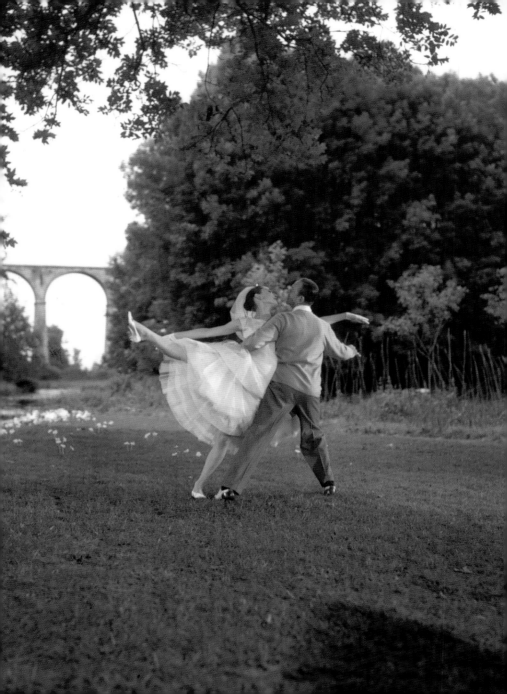

AUDREY WAS ECSTATIC TO BE WORKING WITH one of her idols, Fred Astaire. This was especially notable because while she was growing up, Audrey had dreamed of becoming a dancer, not an actress. Learning ballet was a refuge from the hardships of her childhood in occupied Arnhem during World War II. She even used her talent to give performances that raised money for the Resistance, surreptitiously fighting against the Nazis. She continued her training in the art of ballet in England after the war, but by then her height and age made it unlikely she would ever become a prima ballerina, so she eventually gave it up. Having the opportunity to dance in *Funny Face* was a particular joy for Audrey.

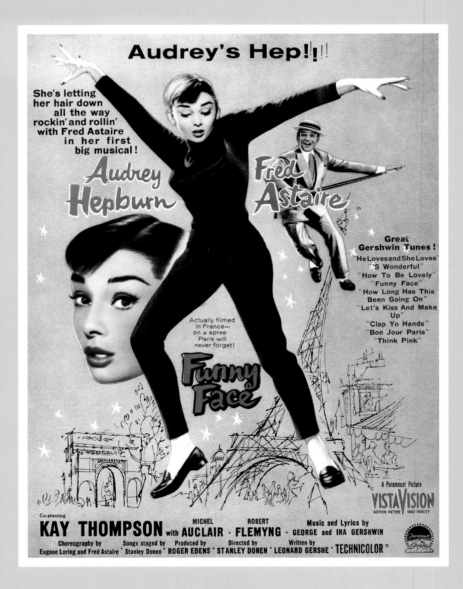

AUDREY AND GIVENCHY

ASTAIRE NOTED, "SHE TOOK OFF ON A DANCE whirlwind that had been bottled up for years." For her number in the café, Audrey famously wore head-to-toe black, except for white socks, which highlighted her dancing feet. Despite the film's great emphasis on fashion, advertisements for *Funny Face* didn't actually play up that angle. Instead, they announced "Audrey's Hep!!... She's letting her hair down all the way rockin' and rollin' with Fred Astaire in her first big musical!" The film featured songs by George and Ira Gershwin.

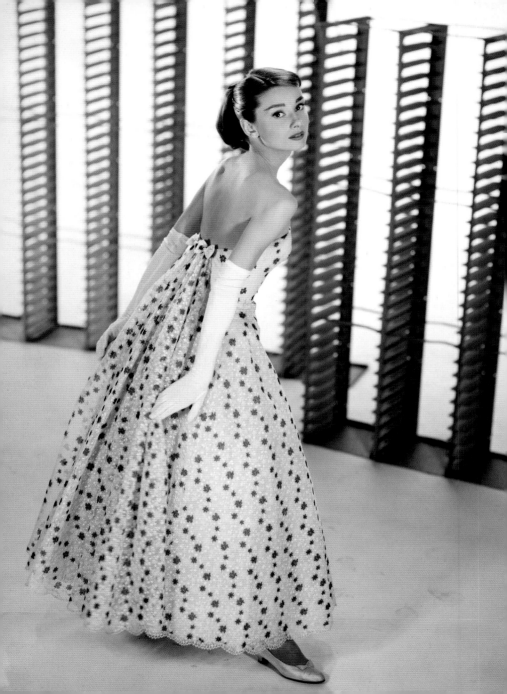

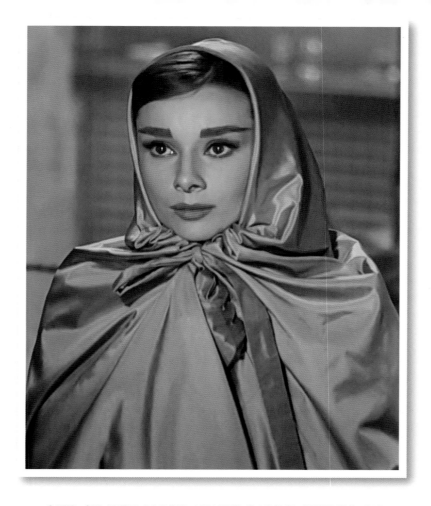

ONE OF THE MOST AVANT-GARDE STYLES ON display has Jo wrapped up with a long silk cape over her head and held tightly under the neck, with only her face visible. Underneath is revealed a gorgeous gown bearing a chiffon overlay (pictured at left).

JO'S ONE-WOMAN FASHION SHOW TOWARD THE film's finale featured even more divine dresses and suits—looks "inspired by the *Quality* Woman." Among the four Oscar nominations that *Funny Face* received was a nod for Best Costume Design. This time, Givenchy did not remain anonymous.

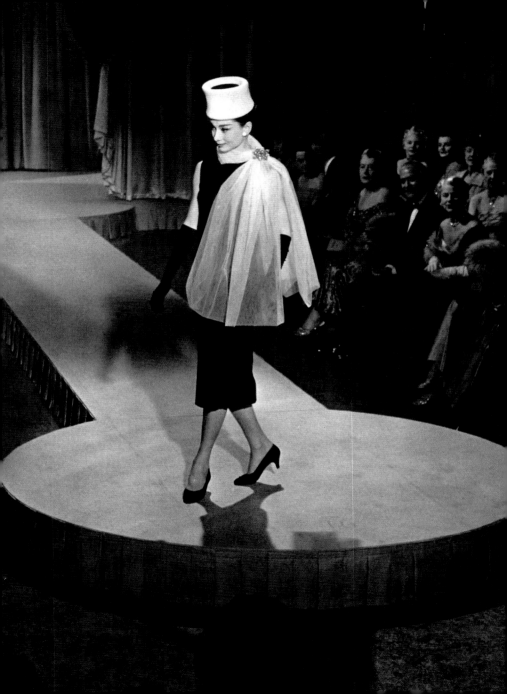

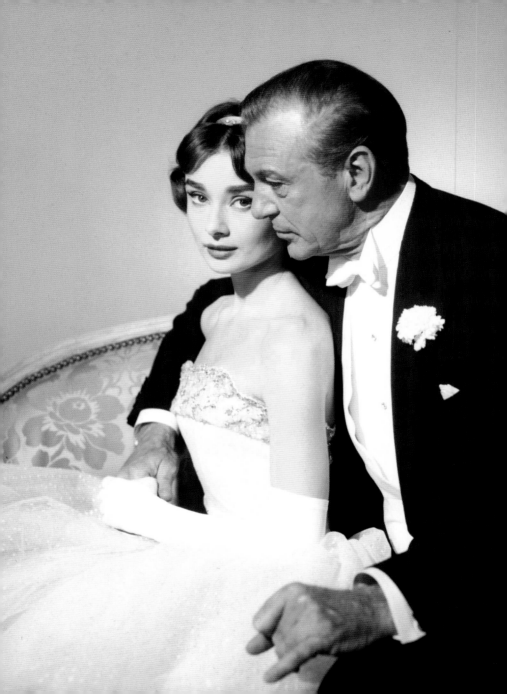

# LOVE IN THE AFTERNOON

AUDREY HEPBURN FANS WERE TREATED to a second new release of hers in 1957: *Love in the Afternoon*. Though it was not as perfect a fit as *Funny Face* was for Givenchy fashions, it allowed the star and designer the pleasure of working together on back-to-back films. In *Love in the Afternoon*, Audrey played Ariane, a music conservatory pupil whose father makes a living as a private detective specializing in the investigation of extramarital romance. While one might ask how this young student can afford such finery as the work of a master couturier, the simple answer is, *who cares?* She looks divine, and audiences are regaled with another stunning array of fashions. The collection of looks is indeed supremely elegant, but with their clean lines and lack of ostentatiousness, they do seem to fit the humble and endlessly endearing Ariane.

Costarring Gary Cooper as Ariane's love inter-est and Maurice Chevalier as her father, *Love in the Afternoon* was based on the Claude Anet novel *Ariane*. Helmed by *Sabrina* director Billy Wilder, the picture is a sparkling romantic comedy with dialogue that rings with saucy, sophisticated humor from start to finish.

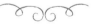

"I'm the girl
in the afternoon—
the aperitif, as we say
on the Left Bank."

−ARIANE CHAVASSE

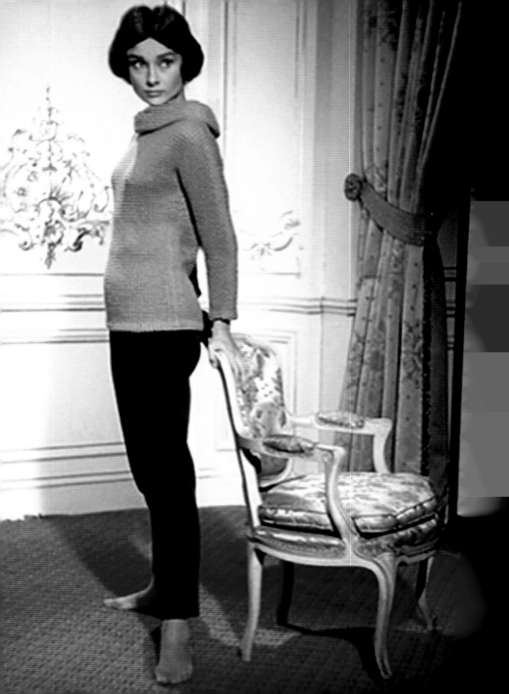

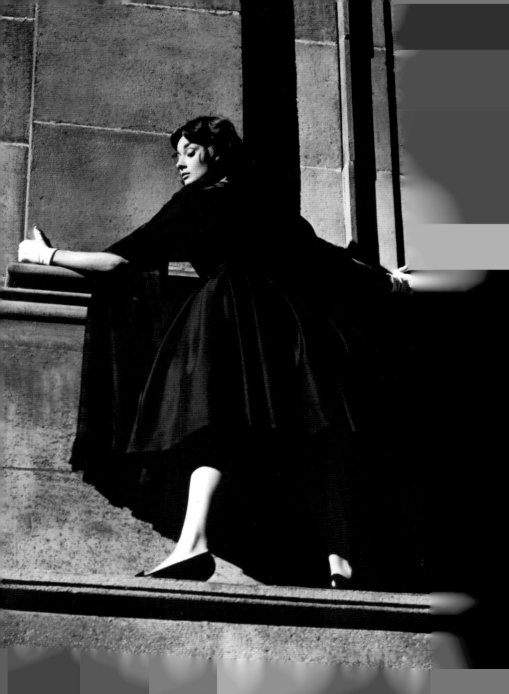

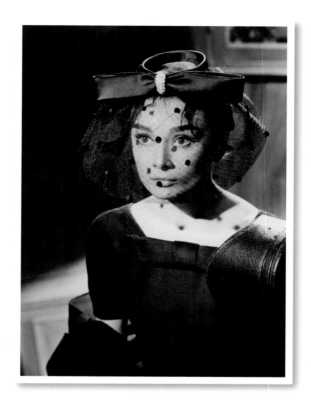

CONSERVATORY CHIC—ARIANE, A STUDENT OF
the cello, wears a simple-but-lovely black dress for
her classes. The dress features a drop torso and
tea-length cut—two staple features in this period
of Givenchy-for-Audrey. At one point in the film, it
becomes necessary for her to scale a wall wearing
this dress. A hat is also added to the ensemble as
part of a disguise.

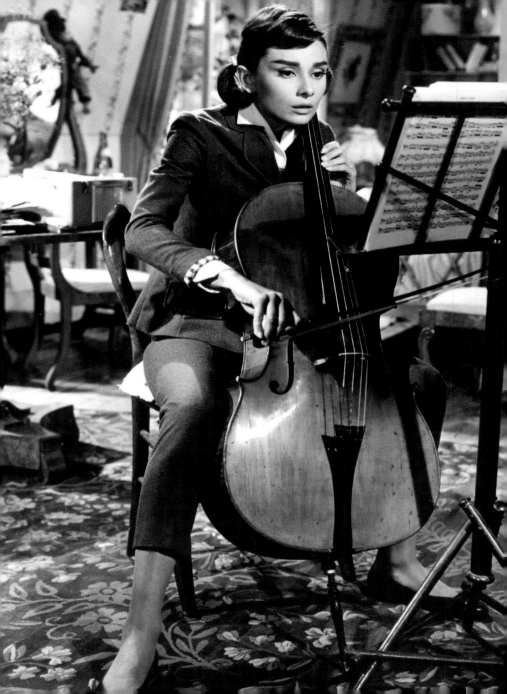

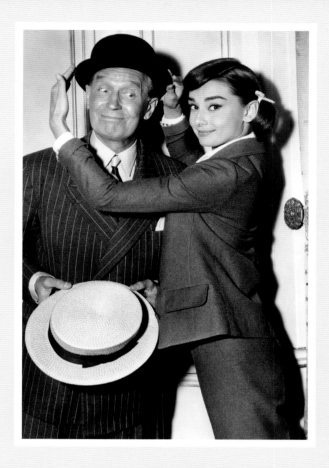

**IN THIS SCENE, AUDREY (PICTURED WITH** Maurice Chevalier) wears a precious suit with slim pants and a single-breasted jacket, out of which peeks the Peter Pan collar of her blouse. She pairs the outfit with pigtails. It's difficult to imagine another leading lady of the era (or any era!) pulling off this look.

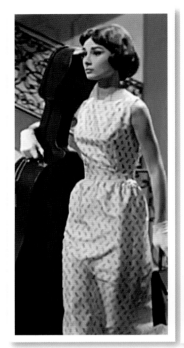
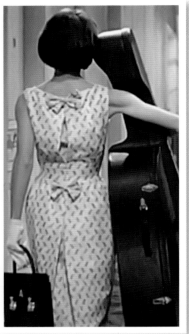

to the Ritz allowed Audrey to model a few of Givenchy's creations organically. A repeat angle of Ariane carrying her cello while arriving at the hotel, going up the stairs, through a hall, and past the camera's eye gave audiences a look at her wardrobe from behind. The first presented in this way is a long, slim-cut dress with a bateau neck-line, decorated in back with bows.

AUDREY'S CHARACTER HAS THE NICKNAME of "Thin Girl" in *Love in the Afternoon*. As her great friend Audrey Wilder (wife ofthe director) observed, "Audrey came to town, and everyone immediately wanted to lose ten pounds." Audrey's weight was maintained through a disciplined lifestyle, but she ate heartily and was naturally slender. At times she even felt too thin. Because she was self-conscious of her hollowed collar-bone, the high *décolleté* Sabrina neckline that Givenchy perfected was one of her favorite cuts.

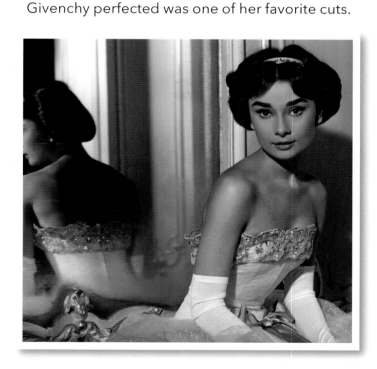

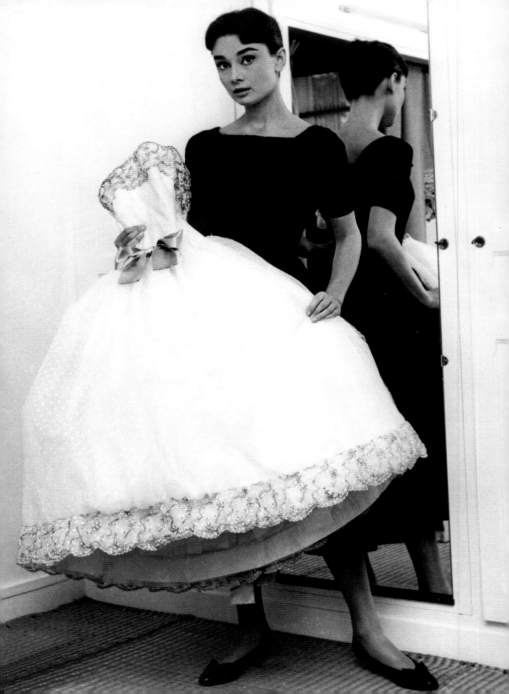

ARIANE WEARS THIS FULL-SKIRTED dress, bejeweled at the top and bottom, to the opera (again, to *Tristan and Isolde*, as in *Funny Face*). It is difficult to believe that Gary Cooper's Frank Flannagan at first doesn't remember his "Thin Girl."

ARIANE THROWS A LUXURIOUS FUR COAT OVER a slim and simple dress before entering Mr. Flannagan's suite. Audrey once said, "I've never even thought of myself as very glamorous. Glamorous is Ava Gardner or Elizabeth Taylor, not me."

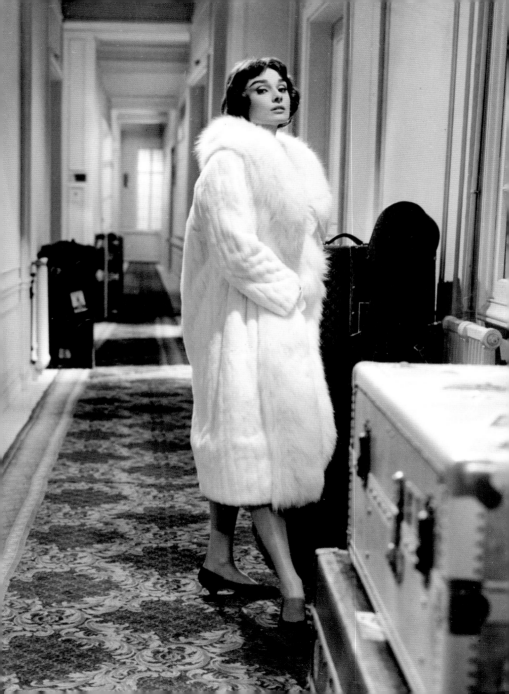

wears a simple white blouse and striped
cropped pants. She later adds a cardigan
to keep warm in the late-afternoon chill.

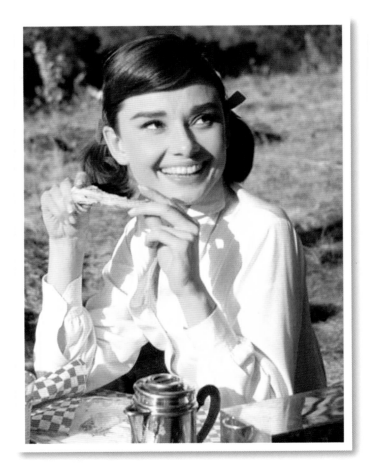

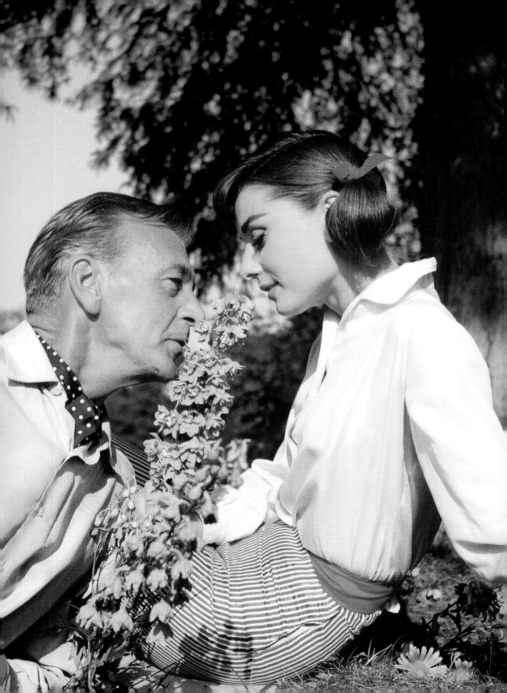

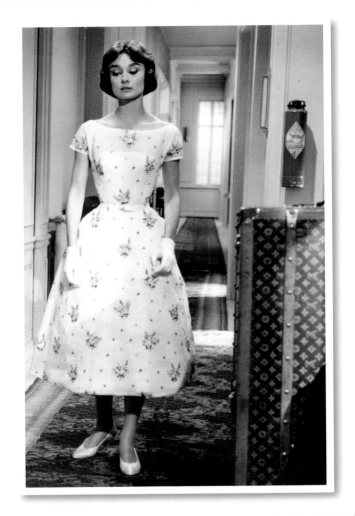

ONE OF THE MOST BEAUTIFUL LOOKS OF *LOVE in the Afternoon* is this floral dress, which is cut below the knees, impossibly slim at the waist, and features an unusual shoulder-to-shoulder-scooped neckline.

**THE PERFECT LOOK FOR BIDDING ADIEU AT A** train station. It proves irresistible as the lovers cannot bear to part ways. Instead, they embrace in a touchingly romantic ending.

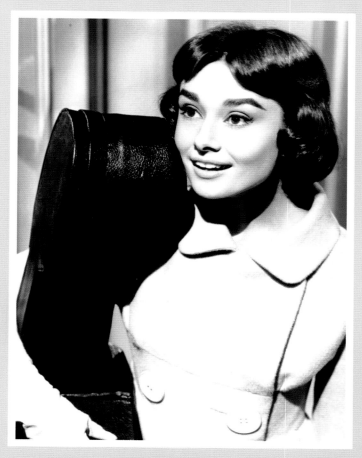

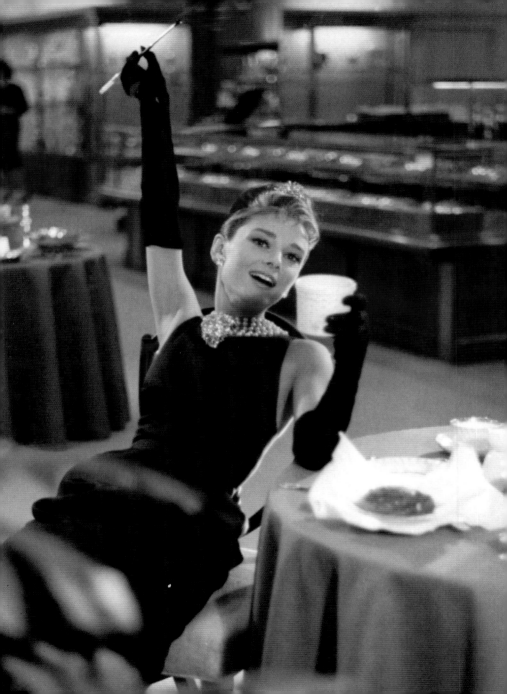

# BREAKFAST AT TIFFANY'S

FTER *LOVE IN THE AFTERNOON*, AUDREY shifted to a series of dramatic roles—such as her Oscar-nominated performance in *The Nun's Story*—and took time off to devote to her personal life, including giving birth to a son, Sean Ferrer, in 1960. The birth of Sean was ever more poignant since it followed multiple heartbreaking miscarriages and Audrey's most cherished wish of all was to have a child. After time off during this idyllic period of private happiness with her newborn, Audrey prepared to return to work in what is arguably the pinnacle of her professional career—her signature performance in *Breakfast at Tiffany's*.

While Givenchy fashions had not been suited to the dramatic films that Audrey made after *Love in the Afternoon*, she had continued to wear his designs for events. He had also worked with style icons Jean

Seberg, Kay Kendall, Brigitte Bardot, and Jacqueline Kennedy. In 1961, Audrey and Givenchy were ready to be reunited for the big screen in what would be their most influential film. In *Breakfast at Tiffany's*, Audrey was going to bring to life on screen Holly Golightly, the Truman Capote heroine who, in the author's original novella, suggests that she could go through life wearing just a black dress and a fabulous rotation of hats.

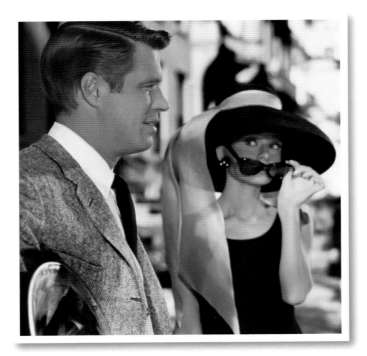

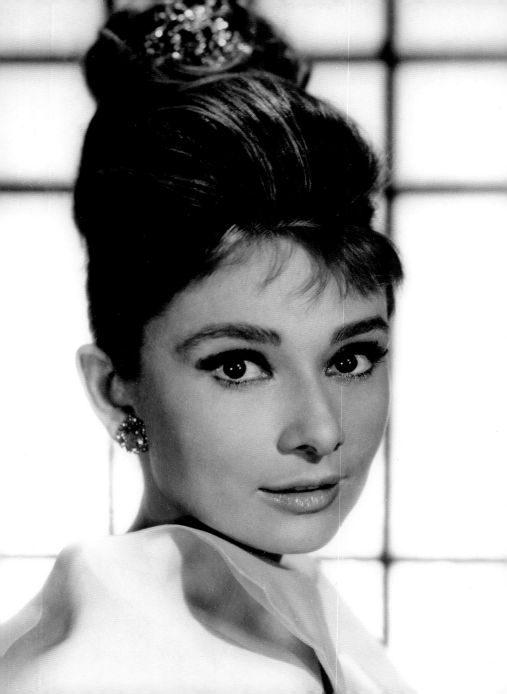

FROM THE FIRST MOMENTS, AS THE CREDITS roll, *Breakfast at Tiffany's* is an instant classic. To the melancholy strains of Henry Mancini's "Moon River," a flawlessly dressed woman steps out of a taxicab in front of Tiffany's jewelry store. It's dusk, and the woman—Holly Golightly—has clearly pulled an all-nighter. If you can't tell it by the coffee and Danish pastry she's enjoying, you can by the decidedly evening-out look of her attire—a sleeveless black satin sheath dress, opera gloves, five-strand pearl necklace, and mini tiara. We don't know it yet, but in this moment, she's shaking off the "mean reds" at the place that calms her down: Tiffany's. What's certain is that we have already bought into this woman's journey.

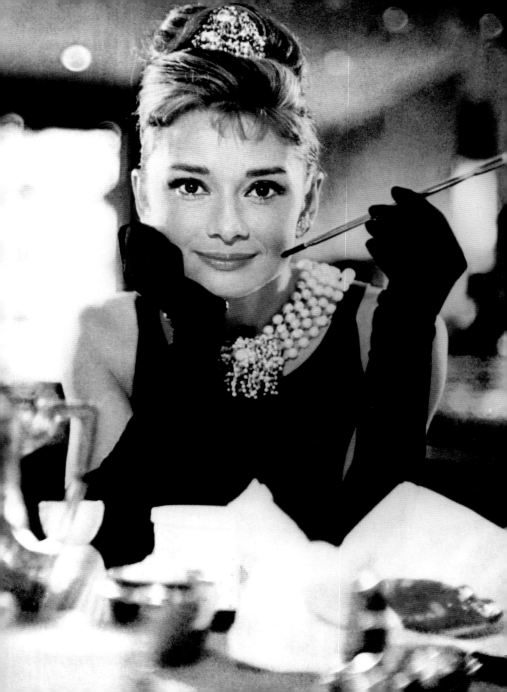

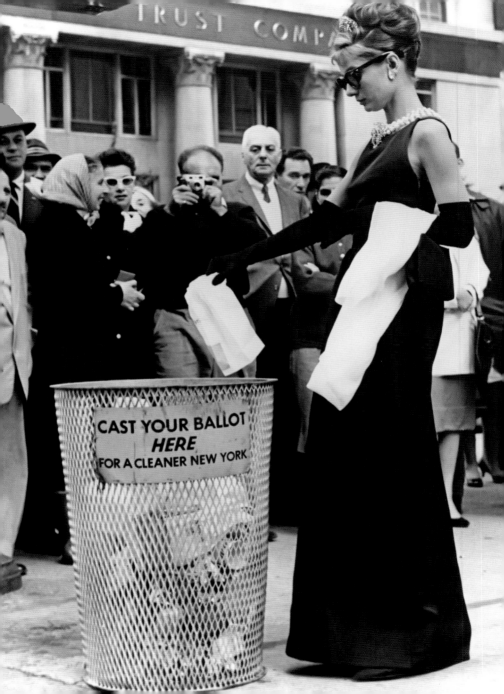

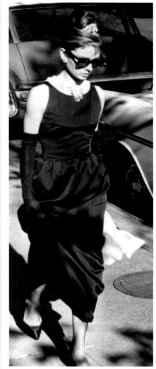

GIVENCHY'S ORIGINAL DESIGN FOR THIS ICONIC Little Black Dress had a slit up the side. Two were made. One was retained in the designer's collection, and the other went with Audrey to Paramount Pictures. The slit was later deemed to be too revealing, so a new adaptation was created with a closed skirt. That studio-approved version seen in the film was reportedly later destroyed, but one of the two original Givenchy creations sold at auction in 2006 for nearly $1 million.

**THE INDELIBLE IMAGE**
of Holly standing outside of
Tiffany's, wearing oversized
sunglasses while peering through the
windows, her upswept, be-streaked
locks adorned with a jewel, and
micro bangs that (seriously) only
Audrey Hepburn could pull off.

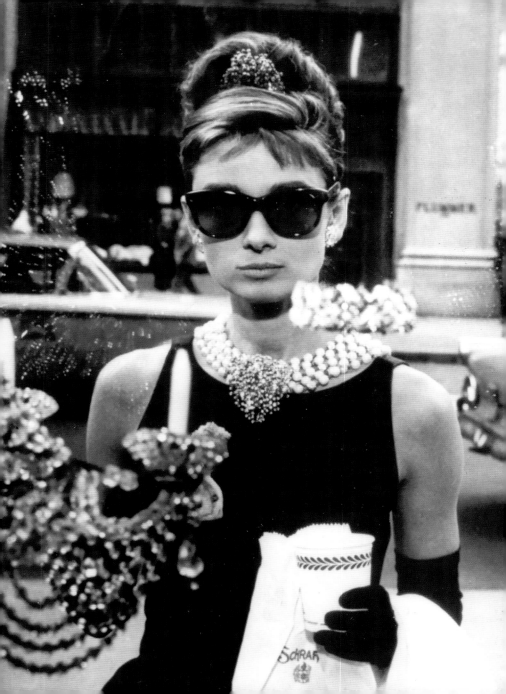

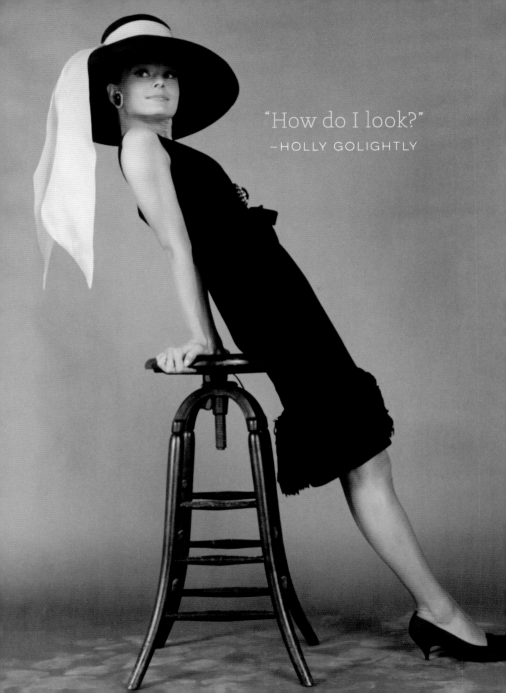

"How do I look?"

–HOLLY GOLIGHTLY

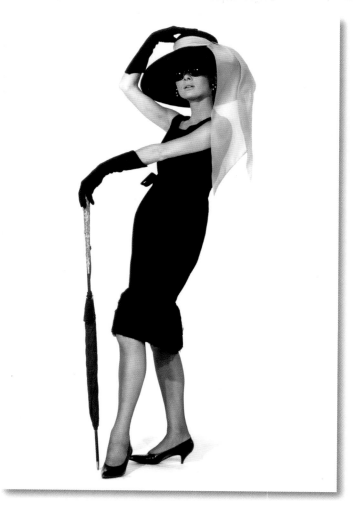

HOLLY WEARS THIS BLACK CLOQUE DRESS WITH a deep-fringed hem to visit a pal at Sing Sing. The dress is lovely, but the Givenchy chapeau is the star of this show.

A SWAN'S DOWN HAT
takes center stage. One of the lessons
Holly teaches us about fashion is that we
don't need an enormous wardrobe—just a
fantastic limited selection of quality pieces.
Audrey, who shared that philosophy, relied
on Givenchy: "You can wear Hubert's
clothes until they are worn out
and still be elegant."

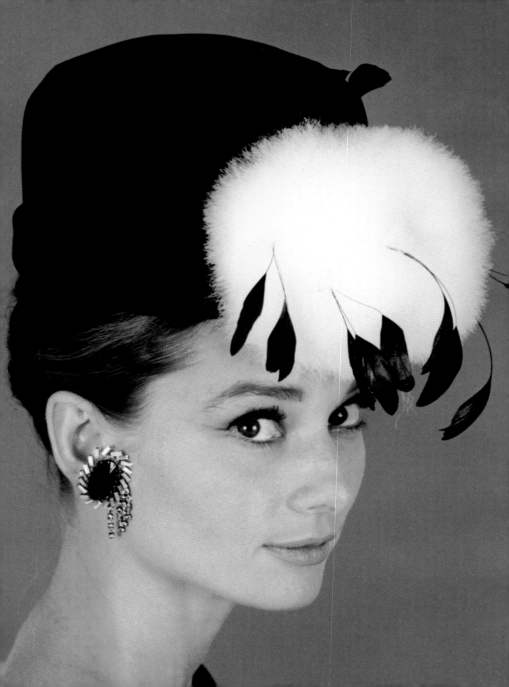

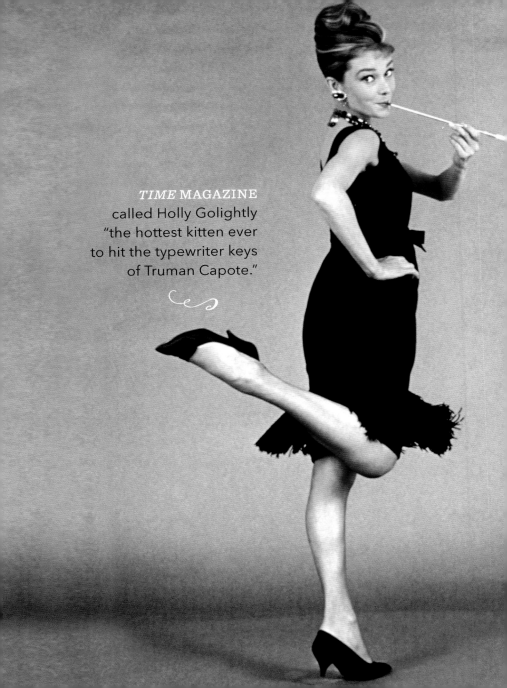

*TIME* MAGAZINE called Holly Golightly "the hottest kitten ever to hit the typewriter keys of Truman Capote."

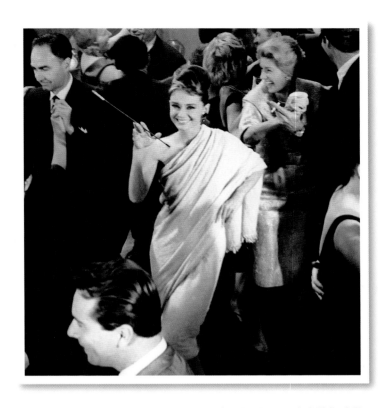

ONE OF THE MOST MEMORABLE LOOKS OF
*Breakfast at Tiffany's* is a makeshift curtain "dress"
that Holly throws on before her party. This auspi-
cious start to the soiree is fitting for the wild night
ahead, which was entirely improvised between
director Blake Edwards and contributions from
the creative bunch of actors featured in the scene.

JUST JEANS AND A SWEATER FOR THE "MOON River" singing scene, in which Audrey gives a touching interpretation of the Henry Mancini–Johnny Mercer song. When a studio executive threatened to cut the scene, Audrey said, "Over my dead body." The song remained—and it undoubtedly helped influence Academy voters, who nominated her for the year's Best Actress Oscar. Mancini fared well, too, as the song took home the Academy Award for Best Original Song. He also won for Best Music Score.

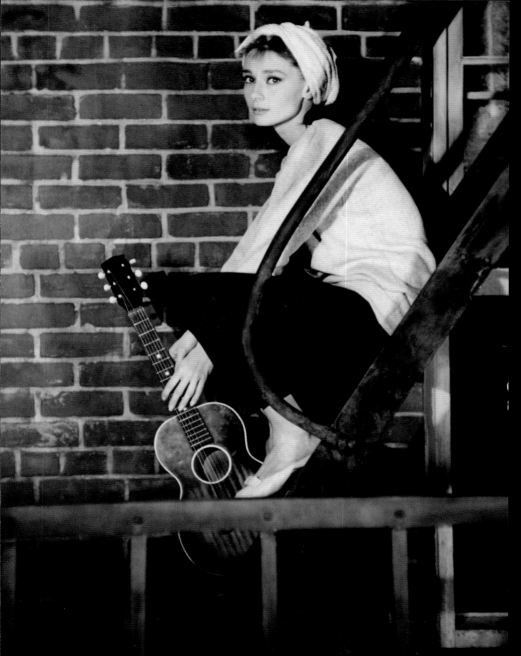

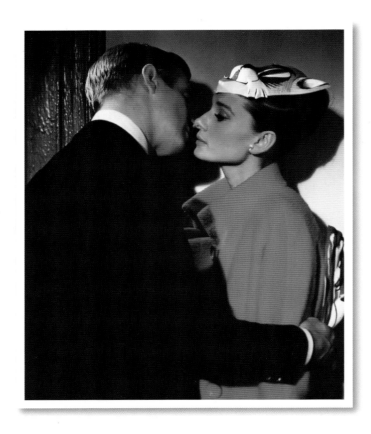

FOR A DAY OF FIRST-TIME ADVENTURES, HOLLY wears an apricot-colored coat with a funnel neckline over a belted gray wool dress. The look is topped off with a mink hat and accessorized with a cat mask, of course.

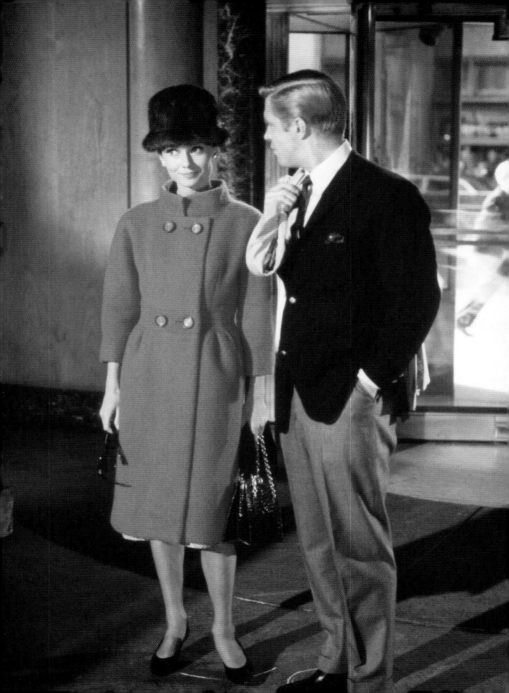

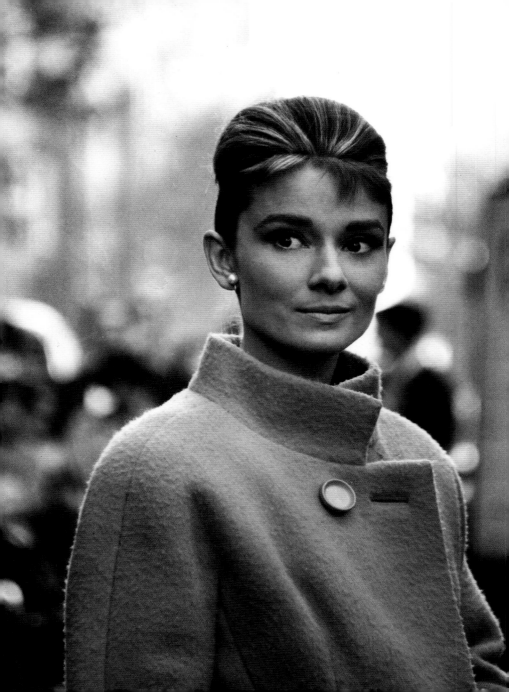

EVEN HOLLY'S HAIR STARTED TRENDS.

## Her streaked locks were unusual for the time.

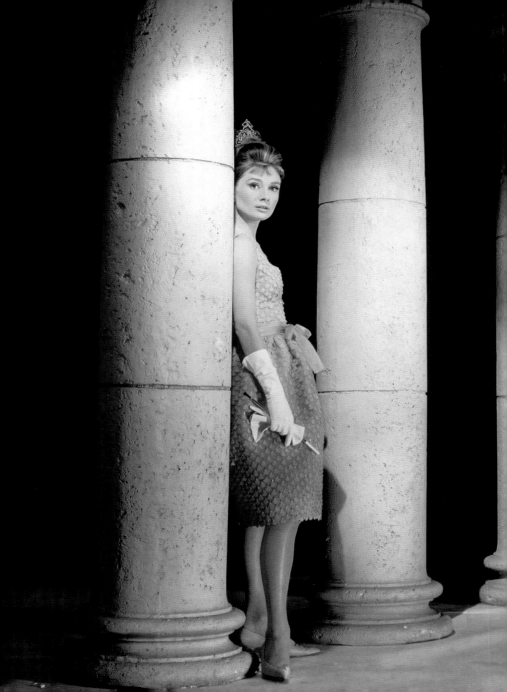

**THE MOST VIBRANT OF HOLLY'S**
wardrobe is this flamingo-pink dress.
Sleeveless and cut along the lines of her
LBD staples, the look is completed with
a pink coat, tiara, spear, and clutch.

GRAY SWEATER WITH COWL NECK,
slim black slacks—the simple
yet chic look worn when Holly
is hauled off to prison.

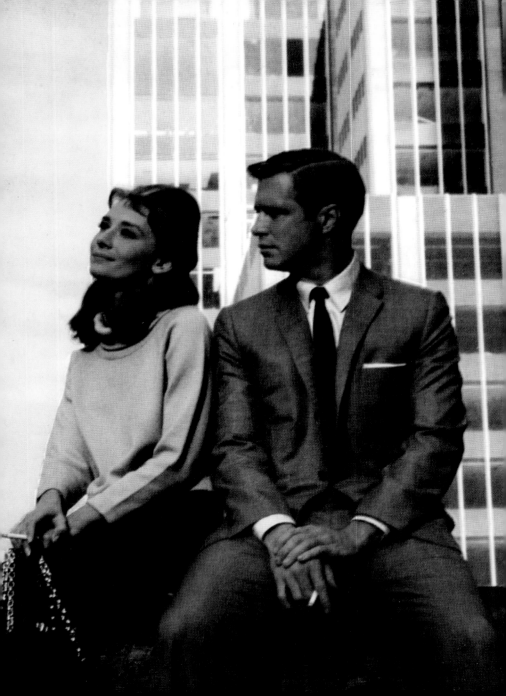

THOUGH SHE FAMOUSLY COLLECTS "$50 FOR THE powder room," Audrey's interpretation of Holly never comes across as the call girl that she is in Capote's original story. Audrey described Holly's sophistication as "just a jazzy facade she creates, because basically she's a small-town girl who's out of her depth." George Peppard, playing a struggling writer, wins her heart.

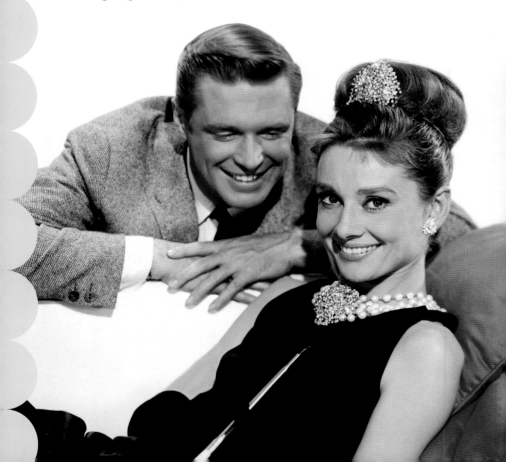

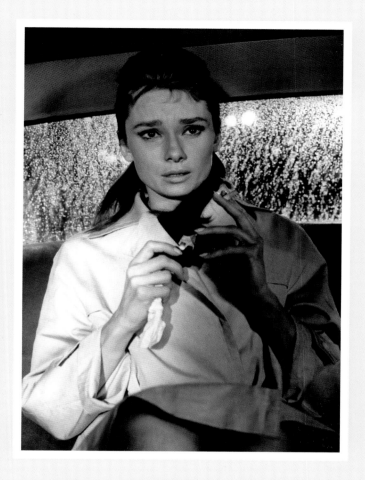

**HOLLY WOULD NEVER BE CAUGHT IN** the rain without a trench. The closet staple closed out a film that has become a treasure in the annals of fashion history.

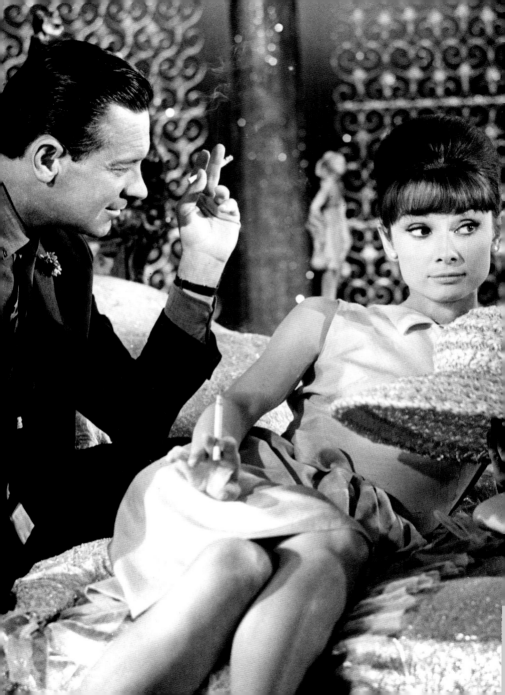

# PARIS WHEN
# IT SIZZLES

*J*N THE 1960s—A FULL DECADE AFTER HER
remarkable debut in Hollywood films—Audrey
was a greater star than ever. She had matured
from the Cinderella-type roles she'd essayed early on
and racked up four Best Actress Academy Award
nominations. After *Breakfast at Tiffany's*, she starred
in the controversial *The Children's Hour* with Shirley
MacLaine. Her next film, *Paris When It Sizzles*, could
not have been more different. In this remake of the
1952 French comedy *La fête à Henriette*, she played the
impressionable Gabrielle Simpson, a muse, assistant,
and daydreaming kindred spirit to a frustrated screen-
writer played by her *Sabrina* costar (and former lover)
William Holden.

The film's intentionally over-the-top satire was
not everyone's cup of tea. Both stars made the picture
in fulfillment of their Paramount contracts, but once it

was made, the studio was nervous about the unusual film's prospects. They shelved the movie until after the release of *Charade* (1963), though *Paris When It Sizzles* was made first. Audrey fared better than Holden. She is as delightful as ever to watch, and reviews of the day were much kinder to her than they were to the rest of *Paris When It Sizzles*.

Highly stylized and whimsical, the film was set in Paris and found Audrey swathed in not only the style, but also the scent of Givenchy, who received screen credit for Audrey's wardrobe as well as for her perfume. According to the designer, the perfume that the credit referenced, *L'Interdit*, "was created in the image of Audrey Hepburn, as a tribute to her beauty and as something *interdit* (forbidden) to others, thereby exclusive." It was made available to the public in 1957, and in the '60s, Audrey's face was featured on advertisements for *L'Interdit*. It has since been cited as the first official "celebrity perfume."

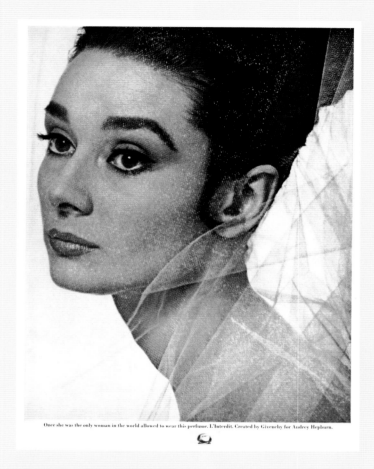

Once she was the only woman in the world allowed to wear this perfume. L'Interdit. Created by Givenchy for Audrey Hepburn.

ADVERTISEMENTS FOR GIVENCHY'S PERFUME read: "Once she was the only woman in the world allowed to wear this perfume. *L'Interdit*. Created by Givenchy for Audrey Hepburn."

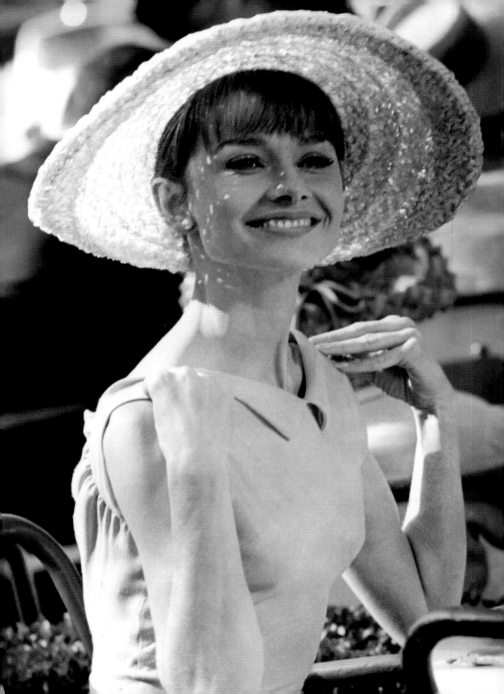

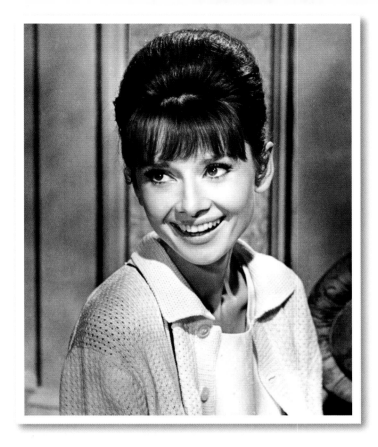

THE FASHIONS FOR *PARIS WHEN IT SIZZLES* were as bright and colorful as its Parisian settings. The fantastical adventures allowed Audrey and Givenchy to stretch their wings: Givenchy created everything from simple secretarial-style dresses to medieval costumes for Audrey to wear as Gabrielle.

Audrey wore cream-colored
silk brocade with black velvet trim
around the neckline of this ensemble.

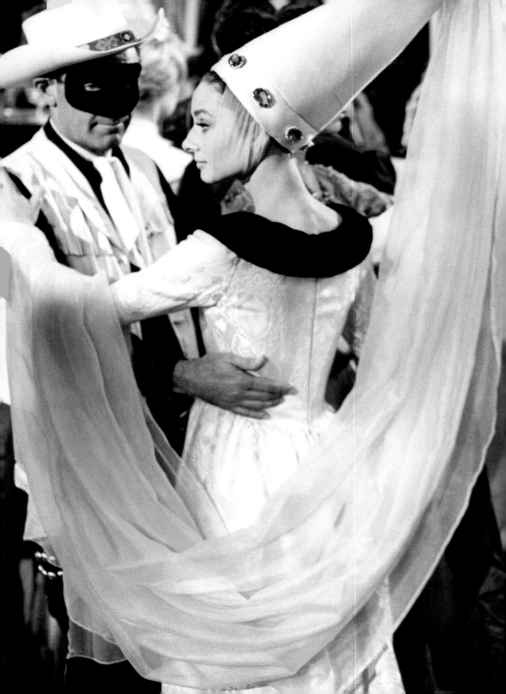

**PASTEL COLORS WERE THE ORDER OF** the day for Gabrielle Simpson. As Audrey always said, she relied on Givenchy's clothes to help her create a character, and the light colors befit this effervescent film.

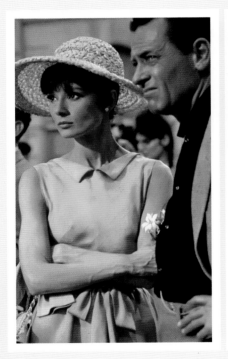

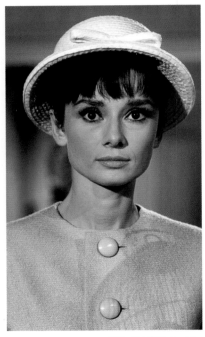

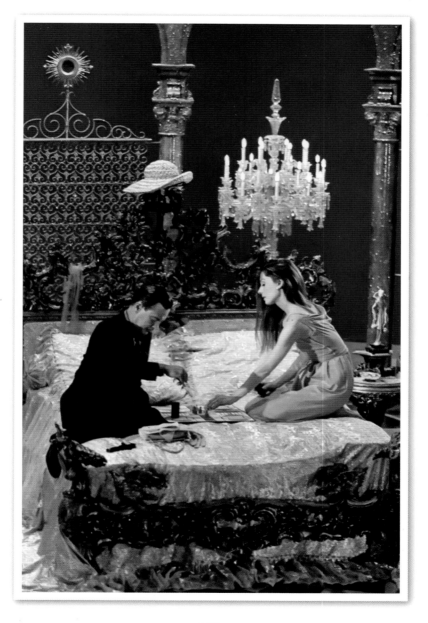

PARIS WHEN IT SIZZLES

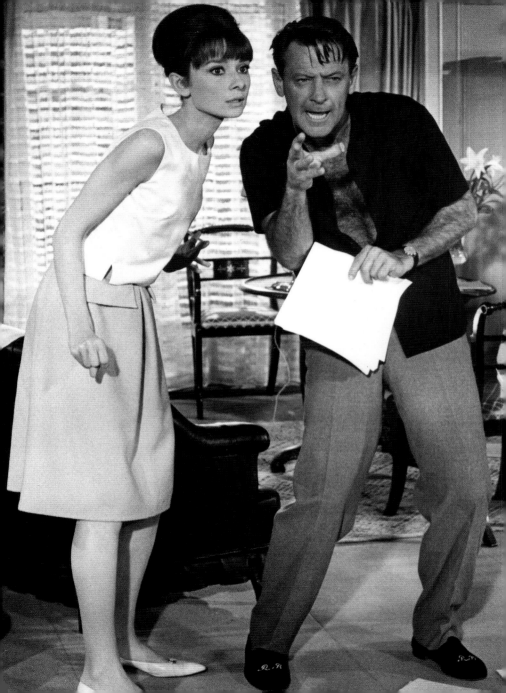

WITH WILLIAM HOLDEN. ALTHOUGH STILL married to his wife of more than twenty years, Brenda Marshall, the actor later admitted it had been difficult for him to work with his former *Sabrina* flame, Audrey, in *Paris When It Sizzles*.

"Every morning when I wake up and I see there's a whole new other day, I just go absolutely ape."

–GABRIELLE SIMPSON

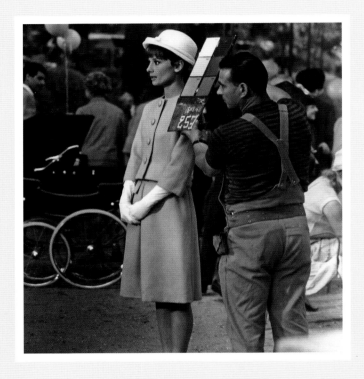

**THE STAR STROLLS IN**
and out of view in the film's opening credits. Here, she awaits her cue on set.

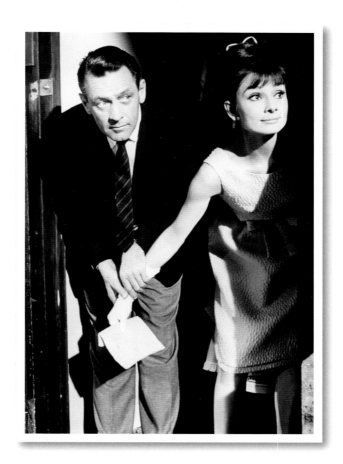

THIS IS MUCH LIKE THE PINK DRESS AUDREY
wore in *Breakfast at Tiffany's*, only simpler. There
are, in fact, several references to *Tiffany's* in *Paris*,
including the movie ending described by Holden's
character, Gabrielle's "I must say, the mind reels"
line, and the popularity of the "prostitute with the
heart of gold" discussed for entertainment value.

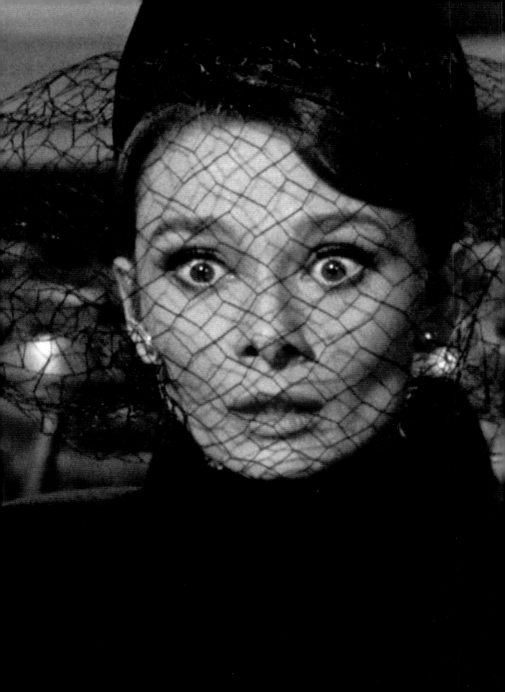

# CHARADE

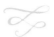

*A*UDREY WENT ALMOST DIRECTLY FROM making one of the few misfires of her career, *Paris When It Sizzles*, into making one of her best, *Charade*. Helmed by *Funny Face* director Stanley Donen, it's an engaging murder mystery that can be enjoyed even in repeat viewings, after the killer's identity has been revealed. Though sprinkled with some genuinely suspenseful moments, the mood is always quickly relieved by Donen's pacing and a superbly witty script penned by Peter Stone. Many critics noted the film's hints of Hitchcock at his finest. Set in Paris, the story called for Givenchy fashions, of course.

After her husband is murdered, Regina Lampert (Audrey) finds herself caught up in a swarm of intrigue with a trio of menacing characters buzzing around her. She relies on a new friend and soon-to-be love interest—Peter Joshua, played by Cary Grant—to keep the buzzards at bay, but soon discovers she

may not be able to trust even him. Grant was thrilled to play this role opposite Audrey, but their twenty-five-year age difference made him uneasy that he would come across as a creepy old man going after a much younger woman. To remedy the problem, the script was rewritten so that Regina pursued *him* in the film, and Audrey played the role with aplomb and tremendous wit.

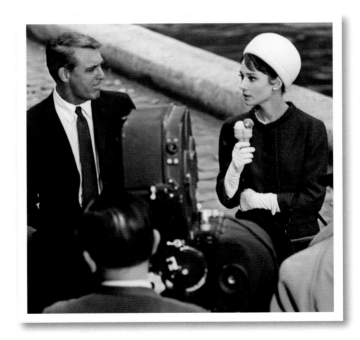

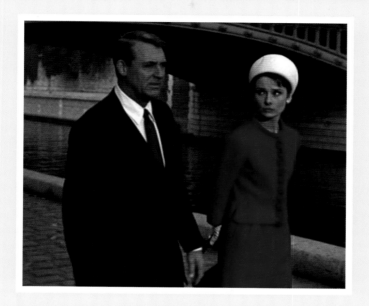

CARY GRANT MIGHT HAVE BEEN AUDREY'S CO-
star ten years earlier: He had been the original
choice for the role of Linus Larrabee in *Sabrina*,
but he was unavailable at the last minute, so Hum-
phrey Bogart stepped in. In the intervening years
before *Charade*, the two stars had not had the
opportunity to meet, though both had the utmost
respect for each other. Audrey was so nervous
upon first meeting Grant that she accidentally
poured red wine all over him. This real-life embar-
rassment inspired Donen to include a memorable
moment of humor in the film: as the pair walks
along the Seine, Regina accidentally whips Peter's
suit with a chocolate ice-cream cone.

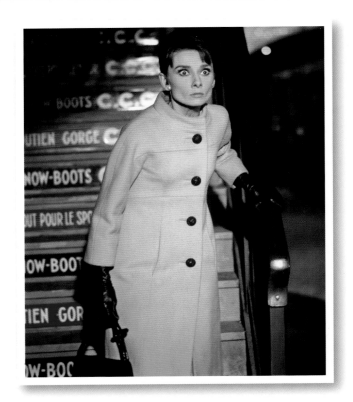

GIVENCHY AND AUDREY MUST HAVE BEEN inspired by the French Alpine settings and low temperatures, because the greatest fashion contribution to the film is a series of eye-catching outerwear looks, starting with the most chic ski outfit possible. The rest of the film showcases divine coats featuring funnel collars, three-quarter sleeves, and decorative buttons, accented by bold hats. Fashion-forward women could still wear the coats decades later.

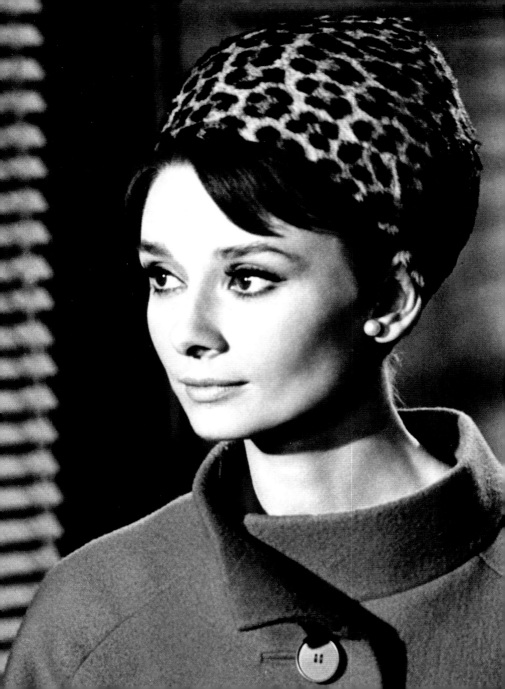

"It is infuriating that your
unhappiness does not turn to fat!"

—SYLVIE

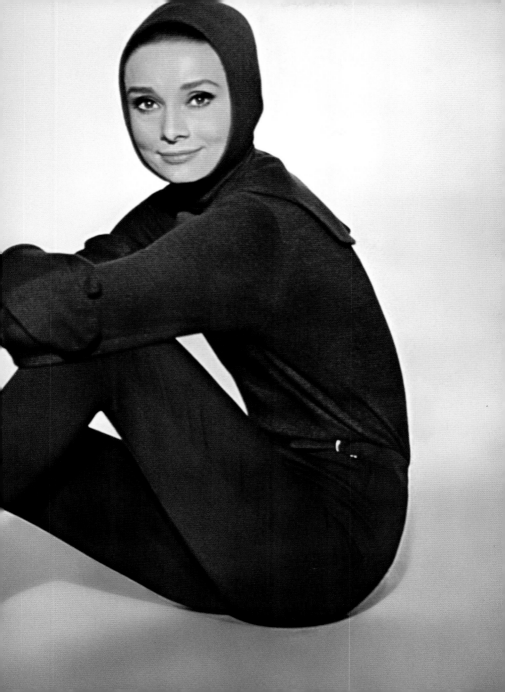

**THE HOODED SKI OUTFIT OF**
*Charade*'s opening scene, before
Regina's life is turned upside down. Very few
women could pull off the tight hood around
her head—let alone the full bodysuit.

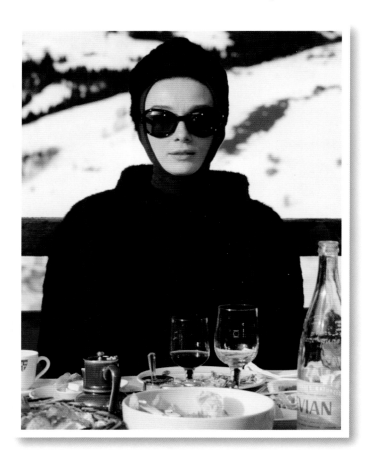

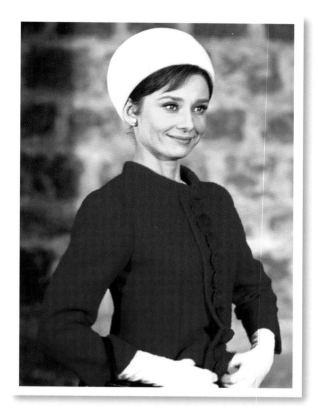

GIVENCHY DESIGNED MUCH OF AUDREY'S WARD-
robe for *Charade* in basic colors of beige, cream,
red, black, and navy. She wore red in the lighter
scene where she drops ice cream on Cary Grant
and again later in the comic scene in which Grant
gives himself a shower while fully clothed. Audrey
said, "Wearing Givenchy's lovely simple clothes,
wearing a jazzy little red coat and whatever little
hat was then the fashion—I felt super."

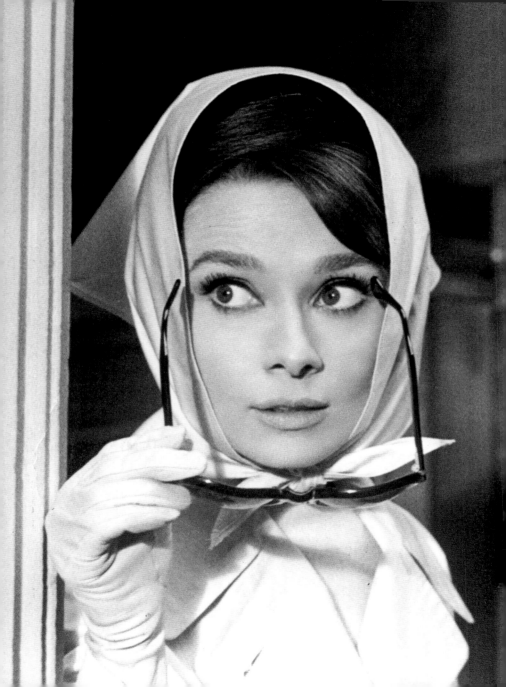

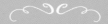

**ONE OF THE GREATEST LOOKS IN *CHARADE* IS** the vision of Regina walking down the street "incognito," wearing a trench coat with boots, gloves, and a scarf around her head, tied under the chin. This is also one of the most amusing moments in the film as she sits down with a German tourist in an attempt to hide and then can't shake the besotted traveler.

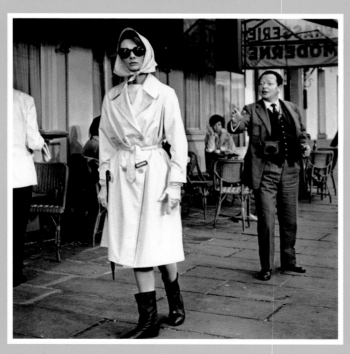

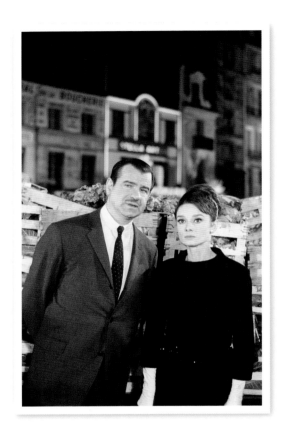

**REGINA CONFERS WITH HAMILTON**
Bartholomew (played memorably by
Walter Matthau) of the CIA.

PETER JOSHUA KEEPS REGINA
guessing the entire running time of the film.

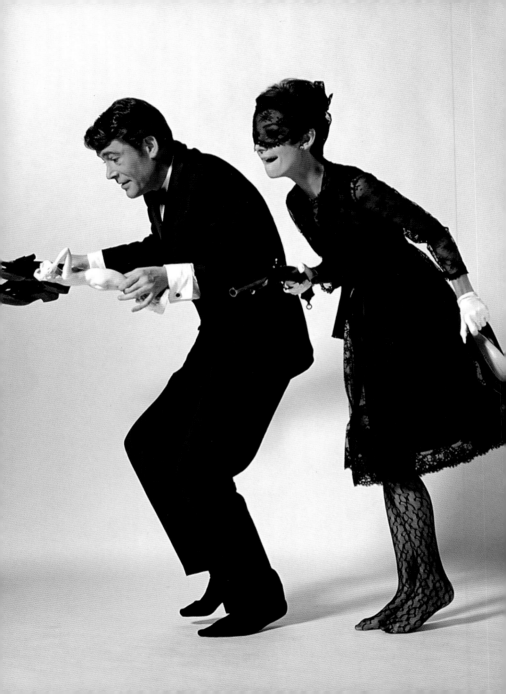

# HOW TO STEAL
# A MILLION

*B*ACK IN A FRENCH SETTING FOR AUDREY
and Givenchy's third film collaboration
in a row, *How to Steal a Million* inspired
pastel visions, an edgy new coiffure for Audrey, and
head-to-toe lace. Audrey's previous film had been the
lavish period musical *My Fair Lady*. In sharp contrast,
she jumped back into a contemporary story with a
vengeance in *How to Steal a Million*. The man behind
the camera was William Wyler, the director who had
brought her to fame in *Roman Holiday* thirteen years
earlier.

Based on a short story by George Bradshaw called
"Venus Rising," *How to Steal a Million* is the tale of an
incorrigible art forger (Hugh Griffith) whose daugh-
ter, Nicole (Audrey), will do anything to keep him out
of trouble, including enlisting a suave crook, Simon
Dermott (Peter O'Toole), to help her steal a supposed

Cellini statue from a museum before it's discovered to be a fake. The night they are to pull off the heist is the only time Nicole doffs her *au courant* mode of dress for her disguise as a charwoman. The getup prompts Simon to utter the immortal line, "Well, it gives Givenchy a night off."

Though Audrey would wear Givenchy for public events and in two smaller films years later, *How to Steal a Million* would prove to be the designer-and-star pair's last big-screen showcase. The mention of Givenchy in the film crystallizes the level of awareness that the partnership of designer and muse had achieved. In the minds of the general public, Audrey was already a fashion icon, and the man responsible for her look was known to be none other than Givenchy.

AUDREY DEBUTED AN ANGULAR
new haircut in *How to Steal a Million*.

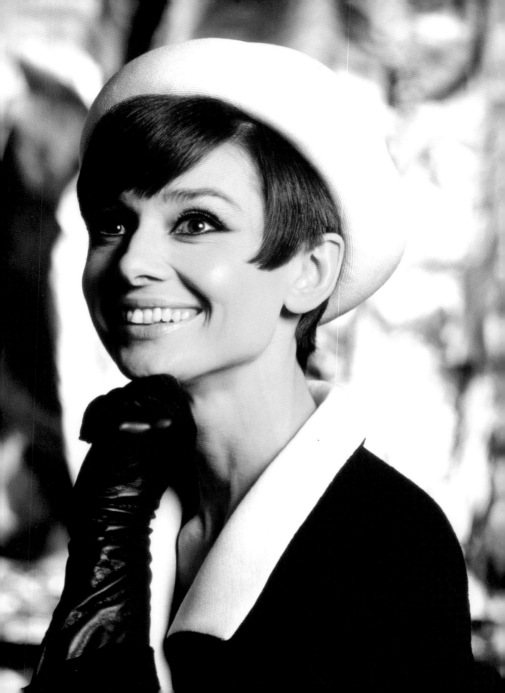

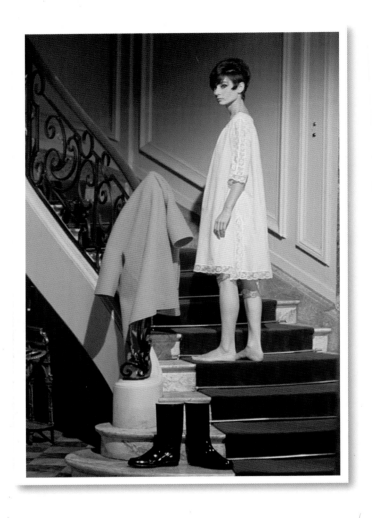

NICOLE CATCHES A THIEF IN THE NIGHT WHILE wearing a pale pink nightgown—later paired with rain boots.

146
AUDREY AND GIVENCHY

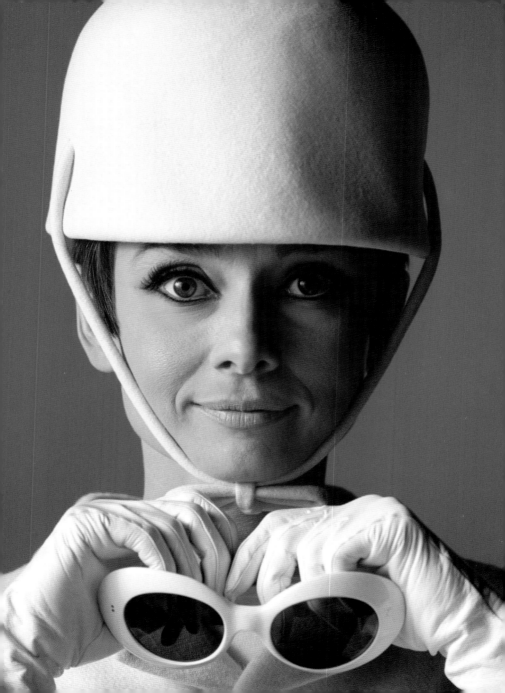

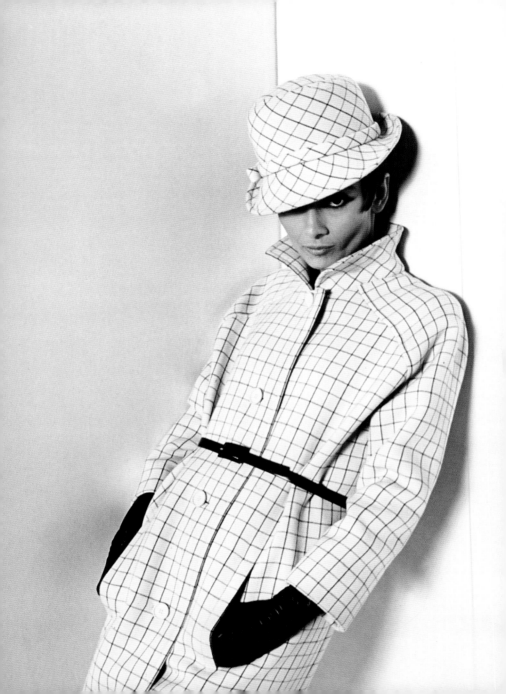

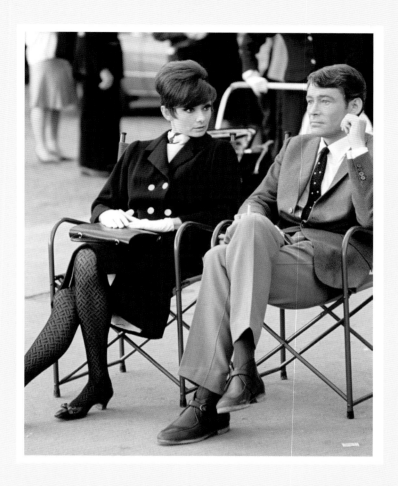

AS IN *CHARADE*, AUDREY MODELED CHIC
Givenchy outerwear in *How to Steal a Million*.

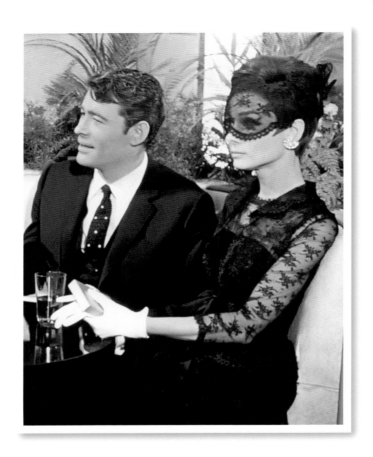

AUDREY WORE PRIMARILY BRIGHT COLORS IN the film, with one particularly memorable exception. This ensemble is a showstopper, and Nicole is every inch the Woman of Mystery in black from the tips of her lace stockings to the lace mask she wears, behind which can be seen a shock of sparkled eye shadow.

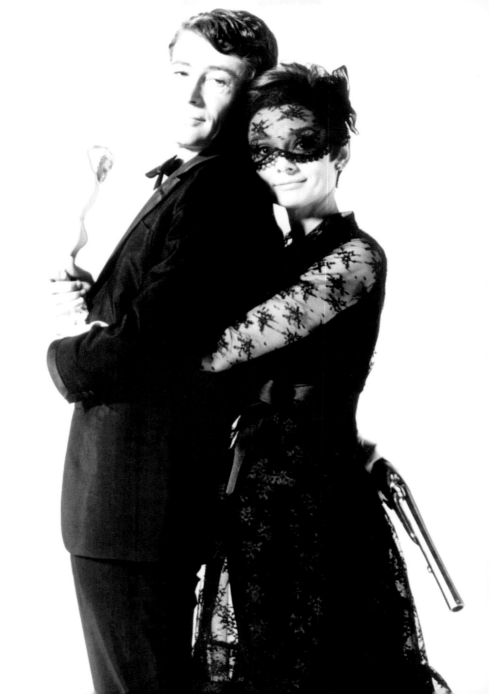

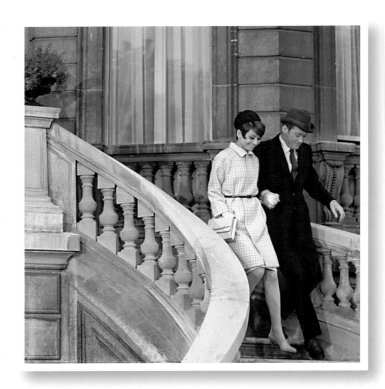

being paired with a leading man her age (in fact, O'Toole was three years younger). The chemistry between the stars helped make *How to Steal a Million* a success with both audiences and critics. The *Today* show's Judith Crist declared it to be "an absolute strawberry-shortcake of a film, with Audrey Hepburn and Peter O'Toole an utterly delightful pair . . ."

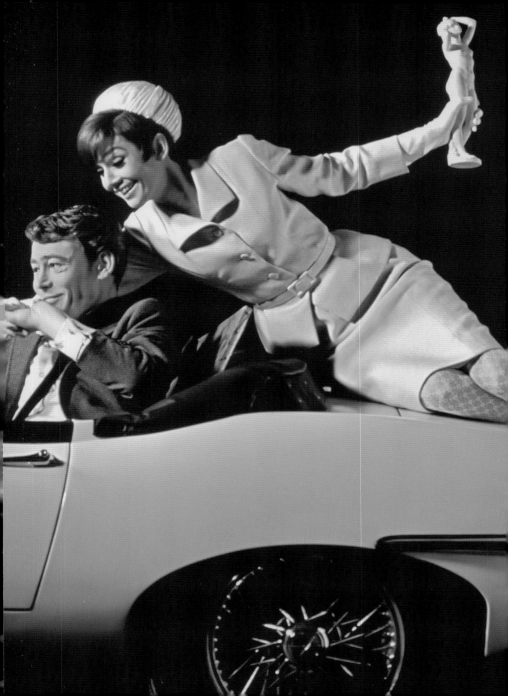

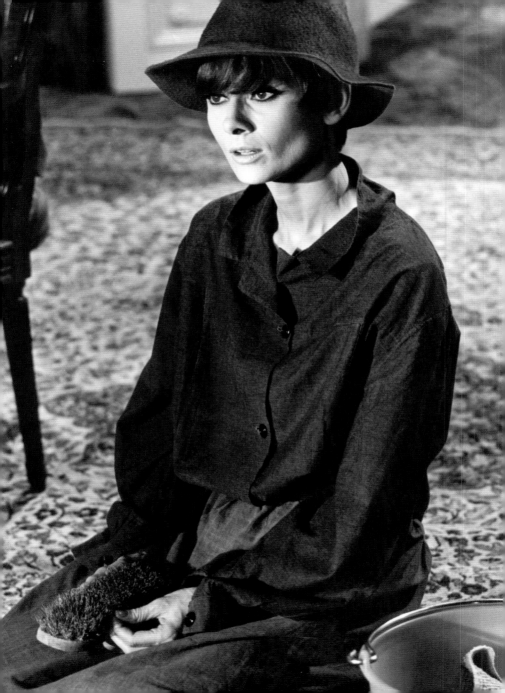

# "Well, it gives Givenchy a night off."

–SIMON DERMOTT

**EVEN WHEN THEY WEREN'T WORKING ON**
a film together, Audrey continued to inspire
Givenchy, who said, "In every collection a part of
my heart, my pencil, my design goes to Audrey."

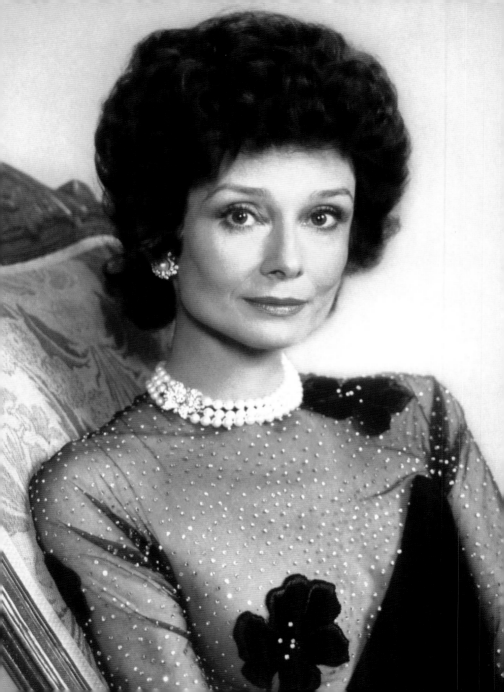

# BLOODLINE

*A*FTER *HOW TO STEAL A MILLION,* AUDREY starred in two of her most inspired films, *Two for the Road* and *Wait Until Dark.* The latter coincided with the devastating breakup of her marriage to Mel Ferrer. Two years later, in 1969, she married Andrea Dotti and spent several years off the screen—and indeed far from Hollywood, living in Italy—to devote herself to her family, including a second son, Luca, born in 1970. *Robin and Marian,* released in 1976, marked her return to films, but it would not be a sustained "comeback." *Bloodline,* a 1979 thriller based on a novel by Sidney Sheldon, followed a full three years later. Led by her *Wait Until Dark* director, Terence Young, Audrey played an immaculately outfitted cosmetics-firm heiress and executive. Critics commented kindly on her Givenchy wardrobe, if not the film itself.

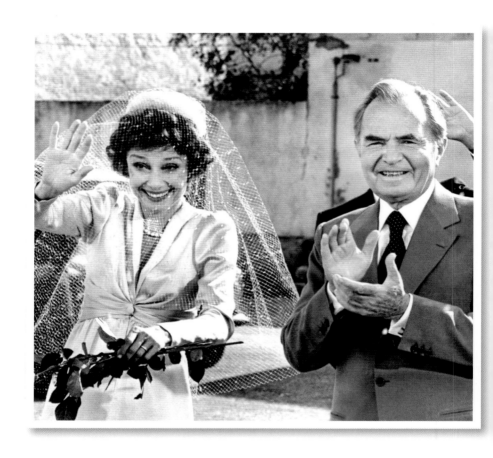

played Sir Alec Nichols in *Bloodline*.

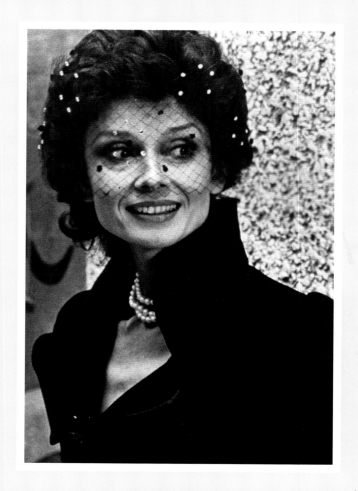

OF *BLOODLINE*, THE *NEW YORK DAILY NEWS'* Rex Reed said, "At fifty, Audrey Hepburn is still vulnerable and doe-like, the perfect victim in Givenchy clothes."

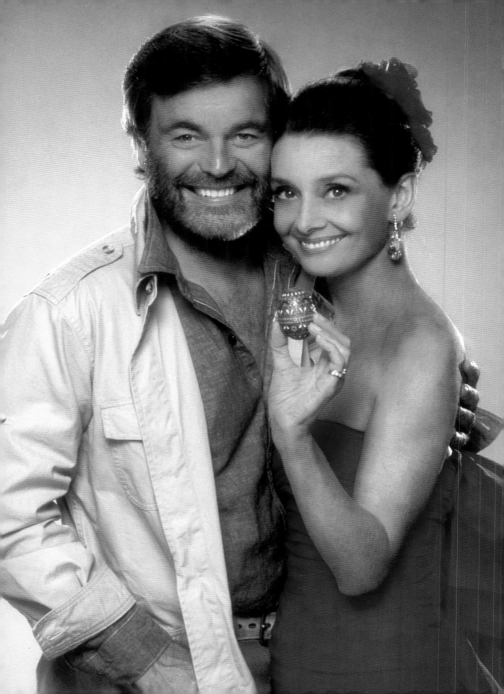

# LOVE AMONG THIEVES

<span style="font-size:2em">A</span>UDREY HEPBURN'S PENULTIMATE MOVIE was not a theatrical feature but a made-for-TV heist caper opposite Robert Wagner, containing elements that reminded Hepburn fans of *Charade* and *How to Steal a Million*. The 1987 production was made inexpensively, but Audrey was able to retain the "armor" that a Givenchy wardrobe was for her. Playing a concert pianist, she has sumptuous fashions as bookends within the plot but otherwise spends most of the running time wearing a red shirt-waist dress. The *New York Daily News'* Kay Gardella commented, "The actress hasn't lost her feel for a light, adventurous, romantic cinematic escapade. Slim and attractive, despite the added years, Hepburn still is the essence of poise and elegance, and can drift down a flight of stairs with the same grace she displayed in *Funny Face*...."

Audrey would make only one more film, *Always* (1989), before retiring from the screen entirely to devote her time to her loved ones and work as a UNICEF goodwill ambassador.

PLAYING THE BARONESS CAROLINE
DuLac in *Love Among Thieves,* Audrey
wore two differently colored versions of
almost the same Givenchy dress.

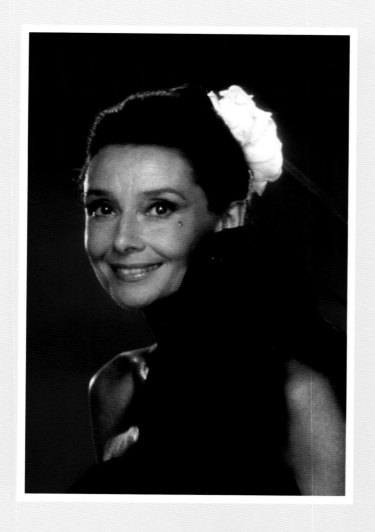

LOVE AMONG THIEVES

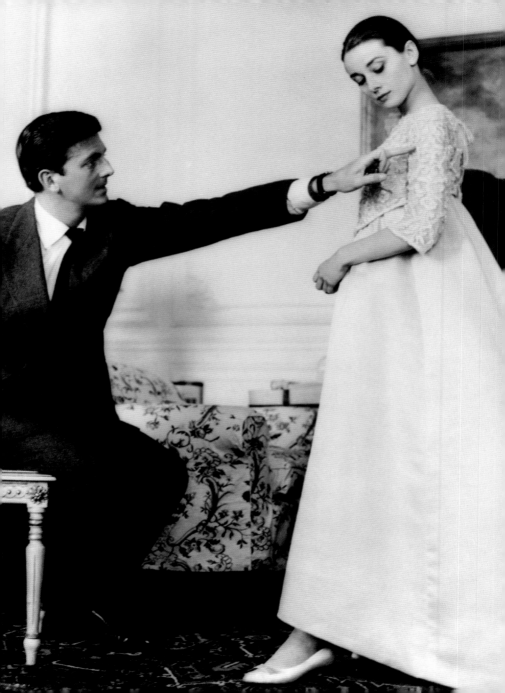

# OFF-SCREEN CHIC

*A*UDREY LOVED TO WEAR GIVENCHY designs off the screen as much as she enjoyed using them to help bring her characters to life onscreen. She was inherently shy, and acting the part of a glamorous movie star outside of her work was not second nature to Audrey. Looking the part helped. She once said, "Givenchy's creations always gave me a sense of security and confidence, and my work went more easily in the knowledge that I looked absolutely right. I felt the same at my private appearances. Givenchy's outfits gave me 'protection' against strange situations and people. I felt so good in them."

Presented here is a selection of highlights among the off-screen fashions Givenchy created for his dear friend, Audrey.

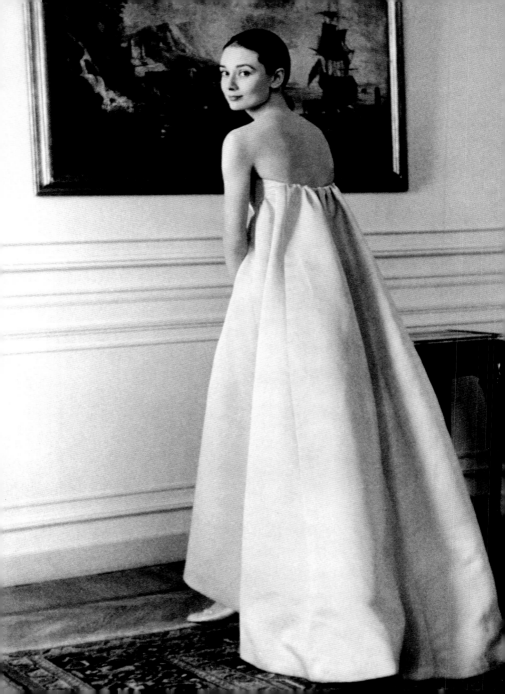

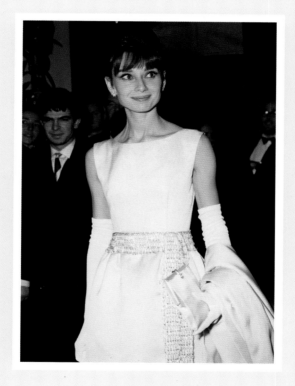

↑ AT THE PREMIERE
of *Breakfast at Tiffany's* (1961).

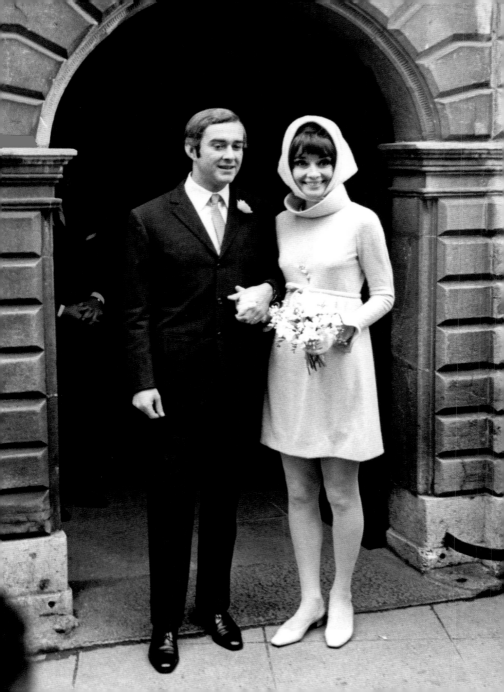

**AUDREY WORE THIS GIVENCHY** long-sleeved pink jersey dress with an empire waist on the day of her wedding to Andrea Dotti on January 18, 1969.

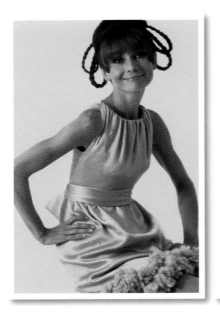

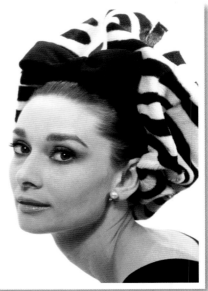

BERT STERN CONDUCTED A REMARKABLY beautiful photo shoot with Audrey for *Vogue* in 1963. Givenchy provided a sublime wardrobe for this session that crystallized Audrey's status as the fashion world's favorite leading lady. She wore silk gowns, embroidered evening dresses, and a selection of unique hairstyles, turbans, and hats.

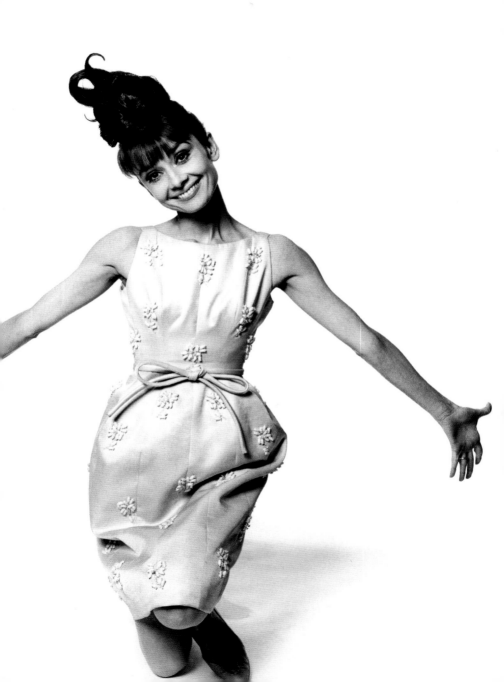

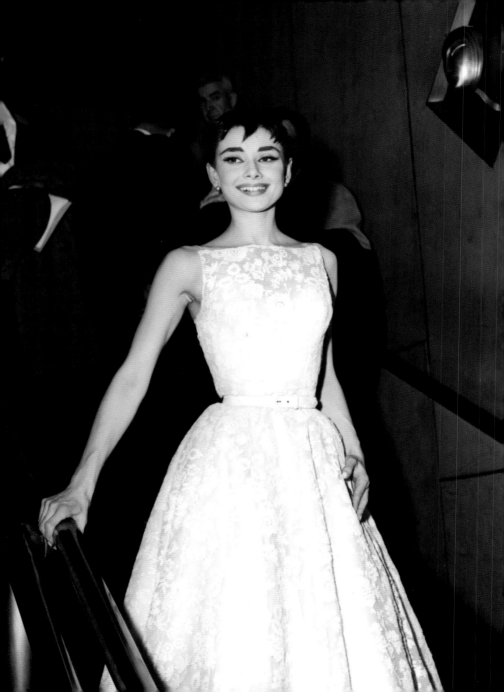

# "It's too much . . ."

## —AUDREY HEPBURN

Audrey was starring in *Ondine* on Broadway at the time of the Academy Awards ceremony in 1954, so she was not in Los Angeles to accept her award for Best Actress in *Roman Holiday*. Instead, she collected her prize after a performance of *Ondine* on the stage of Broadway's Century Theatre. She gave a brief speech that began with an emotional, "It's too much. . . ."

Audrey said her humble words wearing a white floral dress with a belt accentuating her tiny waist. That ceremony in 1954 took place several months before the release of *Sabrina*; thus this night was the first time the public ever saw Audrey Hepburn dressed by Givenchy. There could not have been a more auspicious start for the supremely talented pair who forever revolutionized fashion, with no illusions of ever doing so. In 1995—and again in 2011—*Time* magazine voted this Givenchy creation "the best Oscar dress of all time."

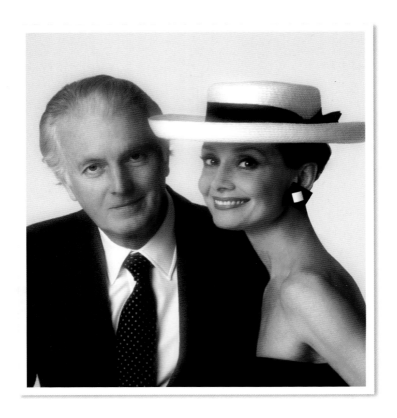

**THE STAR AND DESIGNER.**
Over the course of their forty-year
friendship and professional partnership,
both Audrey and Givenchy became fashion
icons whose collaborations influenced
trends for generations that followed.

# PHOTOGRAPHY
# CREDITS

Front cover (detail), pages 6, 12: © David Seymour/
Magnum Photos

Pages 1, 14, 23, 24, 31, 32, 33, 39, 40–41, 47, 48, 49, 50, 51,
52, 54, 55, 58, 67, 72, 73, 74, 75, 78, 88, 89, 93, 101, 103, 104,
106, 112, 113, 122 (left), 123, 124, 126, 130, 139, 140, 141:
Courtesy Independent Visions

Page 2: Photo by Bud Fraker, courtesy Paramount

Pages 11, 17, 18, 21, 27, 29, 42, 46, 56–57, 60, 68, 81, 84, 86,
91, 95, 96, 97, 99, 108, 111, 118, 119, 121, 133, 138, 145, 147,
148, 152, 168: Courtesy Photofest

Pages 22, 30, 34, 77, 85, 114, 136, 160, 163, 166, 172:
Courtesy Everett Collection

Page 26: © ImageCollect.com/Globe Photos

Page 36: SNAP/Rex/Rex USA/Courtesy Everett
Collection

Page 62: Mary Evans/Paramount Pictures/Ronald Grant/
Courtesy Everett Collection

Pages 64, 100: Paramount Pictures/Album/SuperStock

Pages 82, 83, 92: Courtesy Paramount Pictures

Page 105: Snap Stills/REX Shutterstock

Page 117: Advertising Archive/Courtesy Everett Collection

Page 122 (right): Praturlon/REX Shutterstock

Pages 127, 159: SNAP/REX Shutterstock

Page 132: Courtesy Universal

Pages 134–135: Photo by Vincent Russell, courtesy Universal

Pages 137, 170 (left): Moviestore Collection/REX Shutterstock

Pages 142, 153: Courtesy 20th Century Fox Film Corporation

Pages 151, 154: TM and Copyright ©20th Century Fox Film Corp. All rights reserved. Courtesy Everett Collection

Pages 156, 170 (right): Album/SuperStock

Page 158: ©Paramount Pictures/Courtesy Everett Collection

Page 164: Warner Brothers/Album/SuperStock

Page 167: Photo by Jon Lyons/REX Shutterstock

Page 171: © Condé Nast Archive/Corbis

Page 174: Photo ©Joe Gaffney/Courtesy Everett Collection